IMAGES
of America

AFRICAN AMERICANS
OF SAN JOSE AND
SANTA CLARA COUNTY

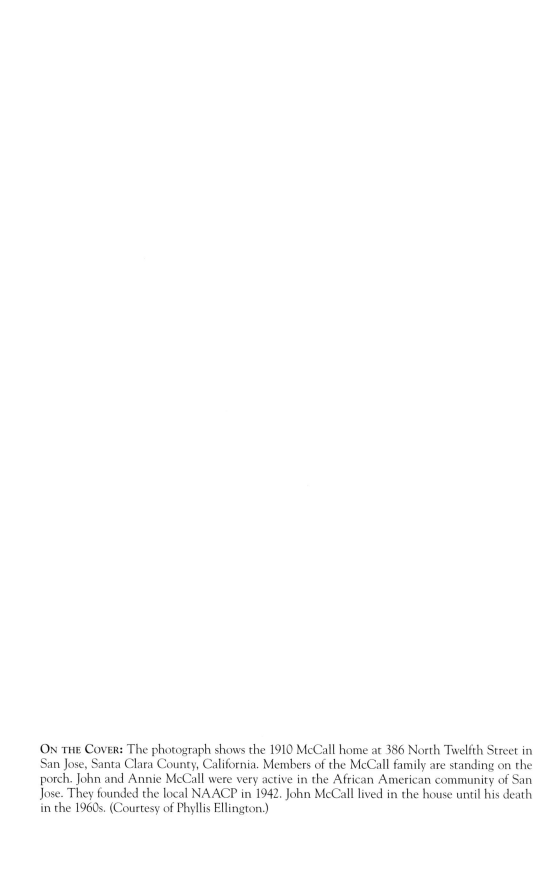

IMAGES
of America

AFRICAN AMERICANS OF SAN JOSE AND SANTA CLARA COUNTY

Jan Batiste Adkins
Foreword by Dr. Steven Millner

ARCADIA
PUBLISHING

Published by Arcadia Publishing
Charleston, South Carolina

Printed in the United States of America

Library of Congress Control Number: 2018952254

For all general information, please contact Arcadia Publishing:
Telephone 843-853-2070
Fax 843-853-0044
E-mail sales@arcadiapublishing.com
For customer service and orders:
Toll-Free 1-888-313-2665

Visit us on the Internet at www.arcadiapublishing.com

*I dedicate this book to the many African American pioneers
who struggled to establish viable communities in San Jose and
throughout Santa Clara County that still survive today.
Also, I dedicate this book to the many families, community organizations,
and churches that have preserved the history, photographs, and stories
of African American residents of San Jose and Santa Clara County.
I hope this book provides the youth of this county and its cities with a
rich overview of the history of its African American communities.*

CONTENTS

FOREWORD

The growth of a village to a metropolitan area affects members of ethnic groups in different ways. What follows is a fascinating depiction of African Americans coming of age in California's Santa Clara County. This is the region that has become the heart of the modern Silicon Valley. As is true for many parts of America, it has had an African American presence since its start. Yes, this Valley's African and African American presence started with the arrival of the Spanish speakers. The pages and images that follow provide an important chronicle of that evolution. Many came on a quest for dignity, while others arrived simply because they were compelled as slaves or laborers. Like all humans, they harbored dreams and hopes that are vividly captured or hinted at in the images and stories that follow. Women and children receive their rightful place within these family tales, and that is how it was. Still is. Both the celebrated and those quietly forgotten are reclaimed in these images. These pages chronicle stories of families such as the Casseys, Whites, Overtons, Ribbs, and Ellingtons, as well as church histories, institutional dynamics, and memorable events. In a real sense, those depicted here were among the earliest and most recent pioneers searching for California dreams. Since this state is the world's fifth largest economy, any of its stories deserve attention, but this is especially true of these stories. Those depicted here were among the strivers and achievers who struggled both to leave segregated Southern settings or frigid Midwestern climes. The qualities of character they demonstrated to achieve in that earlier California provide lessons that should inspire modern arrivals. For if any pioneers had to have the "old virtues" in order to succeed, it was those found in these pages: singers who were able to solo for the "Duke," along with world record holders protesting for human rights. All sprang from here along with the many hidden heroes and "sheroes." Those depicted here truly personified qualities of persistence, dedication to selfless causes, and generosity to strangers, while having a willingness to work twice as hard despite only getting half as much. Many in today's California should be encouraged to embrace the spirit embodied by such pioneers.

—Dr. Steven Millner

ACKNOWLEDGMENTS

I would like to acknowledge the many people who have made this book possible. First, I would like to thank the community people who shared their ideas and discussed their experiences throughout the cities of Santa Clara County. I express my sincere thanks and gratitude to the librarians, archivists, and historians who served as valuable resources for this project: historical archivist Catherine Mills, History San Jose; Erin Herzog, MLK San Jose Library California Room; Mary Boyle, Santa Clara Public Library; archivist Leilani Marshall, Sourisseau Academy, SJSU History Department; Dr. Steve Millner, African American Studies, SJSU; Steve Staiger, Palo Alto Historical Association; Loretta Green, University Zion AME Church of Palo Alto; Forrest Williams, First AME Zion Church, San Jose; Francine Wright Bellison, Emmanual Baptist Church; historian Tom Howard, Gilroy Museum; historian Phill Laursen; Sean Heyliger, African American Museum and Library at Oakland; historian Jean Libby; Rev. Jerry Drino; Hewitt Joyner and Aaron Hicks of Black Legend Award of Silicon Valley; Ocie Tinsley, director of the African American Heritage House; and Milan Balinton, director of the African American Community Service Agency. I also would like to thank the many individuals who invited me into their homes to hear their family stories. The creation of this book involved interviewing over 50 families who shared their history, stories, and photographs. I especially want to thank the Ellington family members who shared the story of their grandparents the Jordans and Ellingtons. Special thanks to Mother Parrish and Queen Ann Cannon and others who shared their family stories of migration from the South and Midwest, Charles Alexander for assistance with photographs, Bob and Melanie Hale for last minute reminders, and Clarissa Moore for her timely suggestions. For the final construction of this work, I want to thank Jean Crawford, Cynthia Barry, and Jittaun Batiste Jones for assisting in gathering research information, scanning photographs, and proofreading. Most of all, I want to thank my husband, Walter Adkins, for his continual encouragement and support throughout this project. I have made many friends on my journey through discovering the history of African Americans in Santa Clara Valley whose friendship I hope will continue for a lifetime.

INTRODUCTION

African Americans of San Jose and Santa Clara County examines African American history in Santa Clara Valley from the 18th century mulatto *pobladores* (citizens) of El Pueblo de San Jose de Guadalupe, who furnished food to the presidios at Monterey and San Francisco of the Spanish empire, to the present day African Americans of Silicon Valley, who continue to create opportunities for the next generation. The book includes an overview of African American pioneers of the 19th century who overcame great odds of slavery, racial discrimination, and economic struggle. They ultimately developed communities with churches, businesses, schools, and social and cultural organizations within Santa Clara County. The book continues with an examination of the pioneer spirit in the early 20th century—those who, during the wave of the great migration, created viable ever-changing community institutions that still exist throughout Santa Clara County today.

For African Americans who migrated to San Jose and other cities in Santa Clara Valley, the 19th century meant settling in California's land of dreams and new beginnings; it was a place of hope. Some slaves who were brought to the valley found freedom. Many free men and women came in search of farmland to establish a family home, while others found opportunities for a business or employment. In 1867, black children could not attend schools with white children, forcing the community, under the leadership of Rev. Peter Williams Cassey, to develop the first school for black children at St. Phillip's Mission and Phoenixonian Institute. These black pioneers fought to abolish California's discriminatory laws prohibiting blacks from testifying against white citizens through the Convention of Colored Citizens held in San Jose in 1863. African Americans often faced employment bias that limited their work opportunities to service or labor. However, these early black pioneers, seeking the land of dreams, faced overwhelming obstacles with courage.

The 20th century was a time of influx and economic success for African Americans in Santa Clara County. After the turn of the century, African Americans came to the Santa Clara Valley as railroad porters, farmers, and laborers looking for work. In some cases, laborers came seeking to escape the hardships of places such as Oklahoma and Arkansas before or during the Great Depression. After World War II, some African Americans came with military experience and education from black colleges and universities seeking opportunities at the start of Silicon Valley's technology boom. The black population grew from 1,718 in 1950 to a high of 55,000 in 1990. The years between 1970 and 1980 saw the greatest increase, when the black population doubled. During the last 30 years of the 20th century, the African American population declined due to the high cost of living and housing, and a shift in technology. Even though many African Americans have moved on to other places, African Americans continue to migrate to Santa Clara County to work in technology and other industries.

One

LIFE FOR SANTA CLARA COUNTY'S BLACK PIONEERS

1770–1899

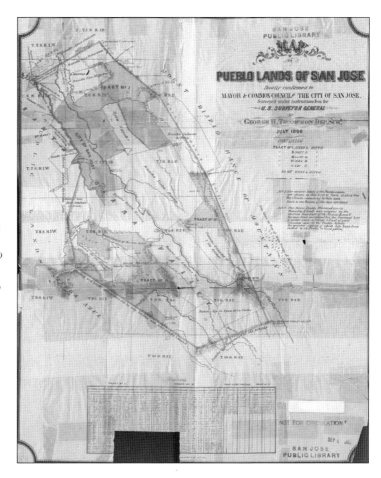

By the 1770s, people of African ancestry traveled to California's coast as laborers on expeditions, as soldiers, and as miners. Some intermarried with Indians and Spaniards and established homes in Spain's California territory. Their children were often identified as mulattos. J. Forbes's *Afro Americans in the Far West* found that in 1790, San Jose's population was 24.3 percent part African. From 1860 to 1900, the population of Santa Clara Valley grew to 60,000 while the black population grew from 87 to 251. This map shows the San Jose area in 1866. (Courtesy of Dr. Martin Luther King Jr. Library.)

People of African heritage began settling in the Santa Clara Valley in 1777. El Pueblo de San José de Guadalupe, depicted in this map, was the first agricultural settlement in the state of California. The pueblo was located near the Guadalupe River, which today would have been near the Guadalupe Freeway, Hedding Street, North First Street, and Hobson Street. The family lots were located beneath the pueblo proper. An analysis of the settlers by researcher Edith Smith of Sourisseau Academy of SJSU shows five pobladores were identified as mulatto. They were Tiburcio Joseph Basques, 25; Philipe Tapia, 42; Joseph Romero, 35; Manuel Amesquita, 21; and Maria Petra Azebes, 17. According to researcher Daniel J. Garr, many more men of African heritage integrated into Spanish, Mexican, and Indian cultures in the pueblo and married, eventually producing mixed-heritage families designated as mulattos. (Courtesy of History San Jose.)

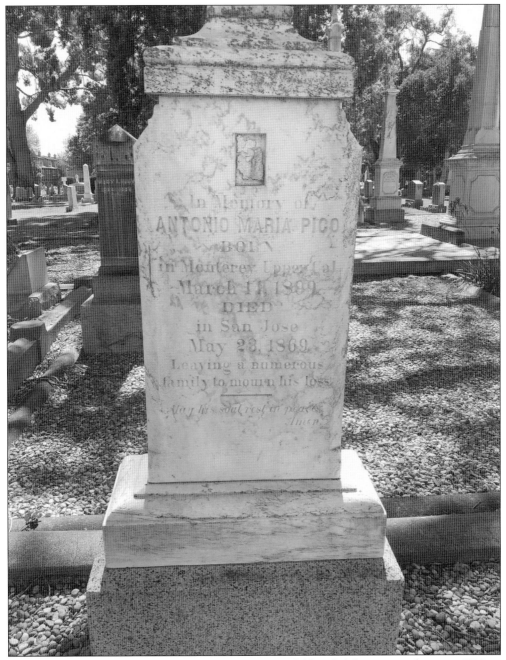

Antonio Maria Pico, cousin of Pio Pico, governor of Alta California, was born in 1809 in Monterey, Alta California. Antonio Maria Pico was the grandson of a mestizo (Spanish/Indian) grandfather and a mulatta (Spanish/African) grandmother. He was appointed *alcalde* (municipal magistrate and judge) of San Jose for many terms. After statehood, Antonio Pico became prefect (administrative leader) of Santa Clara. According to researcher Herbert G. Ruffin II, Pico was a prominent landowner and leader in San Jose. He was part of the constitutional convention in 1849. Pico died in San Jose in 1869 and is buried in the Santa Clara Mission Cemetery. (Courtesy of Santa Clara Mission Cemetery.)

Many free black pioneers who settled in Santa Clara Valley in the mid-1850s to 1860s worked as farmers, laborers, servants, cooks, gardeners, and porters. A few black men, women, and children were brought into the county as slaves. According to Delilah Beasley in *The Negro Trail Blazers of California*, some slaves, such as Mr. and Mrs. William Parker, were liberated in San Jose through the efforts of local abolitionists Rev. Peter Cassey, Harriet Davis, and Rebecca White. Pictured are early black pioneers living in San Jose. (Both, courtesy of History San Jose.)

November 14 1854

Know all men that herby certify,
that the receipt of all demands against
Sampson Gleaves for further services
is hereby fully acknowledged in the
presence of the following witness, and
further state that the same
Sampson Gleaves is forever free.

Asa W. Finley witness James W. Finley

State of California
County of Santa Clara SS. on
this 10th day of November A.D. 1855
personally appeared before me, Recorder
in and for said County) James W. Finley,
to me personally known to be the individual
described in and who executed the foregoing
Instrument, and acknowledged to me
that he executed the same freely and
voluntarily for the uses and purposes
therein mentioned. Given under my
hand and official Seal
at the City of San José, the
day and year last written.
S. A. Clark
County Recorder

Though California was considered a free state, many slaves were brought to California by Southern plantation owners to work for short periods in the mines or on the farms. Sampson Gleaves was brought to Santa Clara County and worked in the home of James W. Finley. This certificate of manumission for Gleaves, signed November 14, 1854, and filed November 10, 1855, in Santa Clara County, released him from Finley. In the census of 1852, the occupation "slave" was designated for least eight persons, indicating slavery was practiced in Santa Clara County. (Courtesy of History San Jose.)

13

Nov 14 1854.

Know all men that I herby certify, that the receipt of all demands for services is herely acknowledged in the presence of the following witness and further state that the same Plim Jackson is to be from this time for ever free

Asa W Finley witness } James W Finly

State of California }
County of Santa Clara } SS. on this 10th day of November A.D. 1855, personally appeared before me, Recorder in and for Said County, James W. Finley, to me personally known to be the individual described in and who Executed the foregoing Instrument, and acknowledged to me that he executed the same freely and voluntarily for the uses and purposes therein mentioned, Given under my hand and official Seal, at the City of San Jose the day and year last written

S. A. Clark,
County Recorder.

The certificate of manumission freeing Plim Jackson from "all demands for services" and making him "to be from this time forever free" was signed by James W. Finley on November 14, 1854, and "filed for record at request of Plim Jackson" with S.A. Clark, a recorder with the County of Santa Clara on November 10, 1855. It was witnessed by Asa W. Finley. The 1852 census indicates that at least 52 individuals were identified as mulatto, black, or colored. (Courtesy of History San Jose.)

14

State of California
County of Santa Clara } ss.:

I hereby certify, that I have this 4th day of August A.D. 1853, at 10½ o'clock A.M. served a Writ of Habeas Corpus on John Bland, by delivering the same to him personally; which writ was directed to him, said Bland, commanding him to bring before the Hon. Judge of the 3 Judicial District Court, at the Court House, in the City of San José at 9 o'clock A.M. the 6th day of August 1853, two colored children, one a male child, named Madison, the other a female child, named Caroline; and then and there to have said writ; the same being issued by order of said judge, and dated August 3, 1853.

J.W. Johnson, Sheriff
By Matthew Chambers, Deputy Sheriff

San José, August 17th, 1853.

This is a document from a court case concerning an alleged attempt by John Bland, a resident of Santa Clara County, to remove two black children—Madison, five, and Caroline, eight—from California to return them to his home state for the assumed purpose of slavery. Abolitionists filed a writ of habeas corpus to recover the children. Court case No. 551, The People of California ex.rel. J.W. Blossom vs. John Bland, commenced on August 3, 1853. Bland was ordered to bring before the Third Judicial District Court (San Jose) by August 6 "two colored children, one a male child named Madison, the other a female child named Caroline." Bland subsequently petitioned the court to be named their guardian, since neither was living with a known parent or guardian. Bland was appointed their guardian until they reached the age of 14 by probate judge J.W. Redman, and required to post a bond of $1,000. It is unknown what happened to Madison and Caroline. (Courtesy of History San Jose.)

James Williams, born in 1817, is thought to be one of the first African Americans to reside in Santa Clara County, in 1852. According to Herbert Ruffin's *Uninvited Neighbors*, "Williams came to California enslaved and worked digging at Negro Hill, a mining enclave for black miners." Once manumitted, Williams settled at Murphy Ranch around 1852. Later, he served as a fire department volunteer and was elected sergeant at arms in 1893 for Hope Hose Company. At one time, a plaque was placed in the headquarters of the Santa Clara Fire Department commemorating his volunteer service. He was also a member of First AME Zion Church and in 1867 served as an agent for the trustees in building the church. Williams died in 1913 and is buried at Mission City Memorial Park in San Jose. (Courtesy of Santa Clara City Library.)

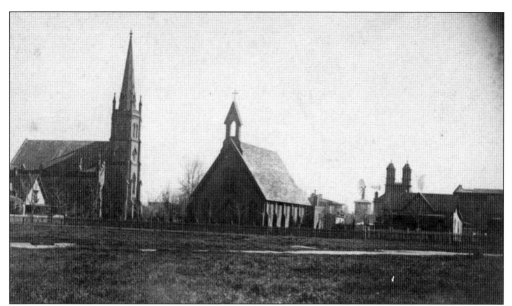

Trinity Cathedral Episcopal Church was constructed in 1863 and is the oldest church in San Jose. Five black families were members in the Trinity congregation, with documented records of baptisms, confirmations, marriages, and burials. Peter Williams Cassey and his wife, Annie Besant Cassey; Annie's mother, Henrietta Lockwood; Peter and Annie's children, Alfred J. White with his wife, Rebecca V., and their children and James Floyd, with his wife, Pauline, and their children; Francis Massey, Harriet Massey, and their daughter Sarah; and Jacob Overton, his wife, Sarah, and their children all worshiped at Trinity from the small nearby black community. Reverend Cassey established St. Phillip's Mission in 1862, where the small community of black Episcopalians worshiped. In 1866, he was ordained as deacon by Bishop William Kip (right). In 1881, Reverend Cassey was transferred to be the rector of the historic black congregation of St. Cyprians in North Carolina. (Above, courtesy of History San Jose; right, courtesy of Diocesan Archives-Episcopal Diocese of California.)

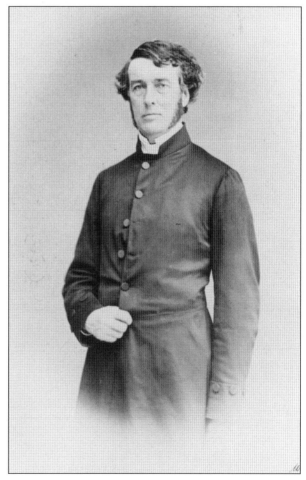

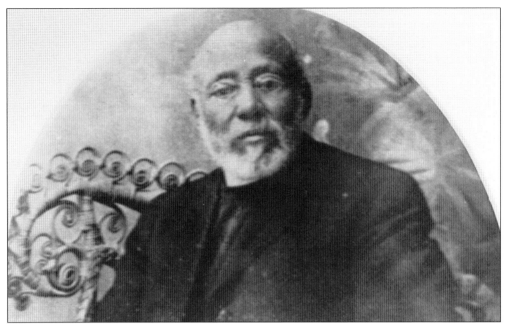

Peter Williams Cassey, born in Philadelphia in 1831, was the son of renowned African American abolitionist and businessman Joseph Cassey. In 1853, at age 22, Peter Cassey arrived in San Francisco and operated a shaving saloon in the Union Hotel. In 1860, he relocated to San Jose and joined Trinity Episcopal Church (below). In 1866, he was ordained a deacon. In response to the desire of black Californians for education, two years later he founded St. Phillip's Mission, a school during the week and a Sunday school for black Episcopalians in San Jose during the weekend. He also established the Phoenixonian Institute, the first black secondary boarding school in the western United States. Cassey also organized the Convention of Colored Citizens of California in San Jose on December 11, 1863, and participated in the 1865 convention, which addressed black laws. He married Annie Besant Cassey, and they raised their children in San Jose. Annie and her mother, Henrietta Lockwood, are buried at the Oak Hill Cemetery in San Jose. Cassey had known Harriet Tubman and believed in freedom for all people. (Both, courtesy of Trinity Church.)

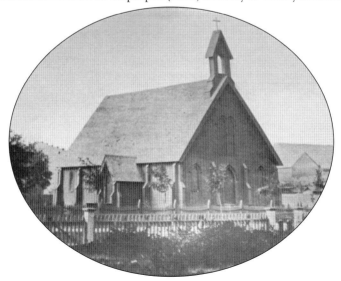

Peter Williams Cassey ran a school for black children at 625 Fourth Street in 1870. He also conducted St. Philip's Mission for black children in Phoenixonian Hall at Third and San Antonio Streets, as well as a Sunday school with 38 pupils. Cassey's San Jose School for Colored Children received financial support from the San Jose School Board from 1865 to 1874. In 1878, the school board voted to close this school and have black children attend regular San Jose schools. In 1880, the state constitution was changed to eliminate separate school systems for different racial groups; however, the state sanctioned separate schools for Asians, Mexicans, and American Indians. It did not ban segregation until 1947. Pictured below are students from other schools for black children in Sacramento and San Francisco. (Right, courtesy of Jan Adkins; below, courtesy of History San Jose.)

SAN JOSE, CAL.

SIXTEENTH ANNUAL SESSION of this Institution commenced on Thursday, August 16th, 1866. The course of instruction embraces all the branches of a polite and useful education. Its aim is to form young ladies to virtue, accustom them to early habits of order and economy, and to cultivate in them those qualities which render virtue both amiable and attractive.

TERMS.

Entrance to be paid but once...$15 00
Board and Tuition, per Session...............................260 00
Washing, per Session.. 50 00
Physicians' fees (unless it be preferred to pay the bill in
 case of Sickness,) per Session............................... 10 00

Piano, Vocal Music, Drawing and Painting form extra charges, but there is no extra charge for the French, Spanish or German Languages, nor for plain sewing and fancy needle work.

PAYMENTS ARE REQUIRED TO BE MADE HALF A SESSION IN ADVANCE.

Pupils will find it much to their advantage to be present at the opening of the session.

SAN JOSE SCHOOL
FOR
COLORED CHILDREN,

This School is pleasantly situated in the southern part of San Jose.

P. W. CASSEY, Principal.

P. S.—Persons wishing to patronize this School can obtain any information regarding terms, &c., by addressing the Principal.

T. W. SPRING & CO.
AUCTION & COMMISSION MERCHANTS,

SANTA CLARA STREET, NEAR MARKET, SAN JOSE
Wholesale and Retail Dealers in

CLOTHING, HATS, BOOTS, LADIES' AND CHILDREN'S SHOES,

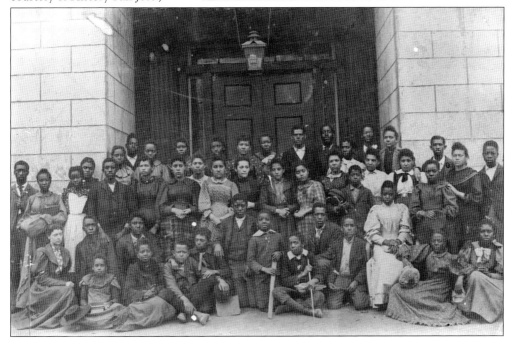

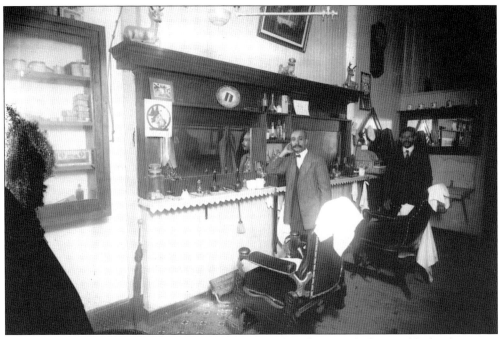

This photograph shows Alfred White, of San Jose, during the 1860s–1870s. He was a barber and was listed in both the 1860 and 1870 census. White was married to Rebecca V., sister of Annie B. Cassey. They raised seven children in San Jose. (Courtesy of History San Jose.)

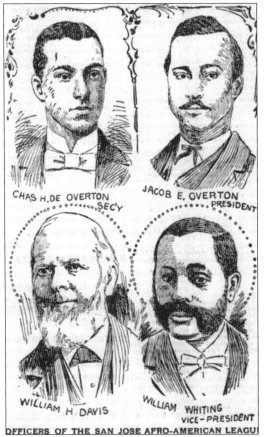

CHAS H. DE OVERTON
SEC'Y

JACOB E. OVERTON
PRESIDENT

WILLIAM H. DAVIS

WILLIAM WHITING
VICE-PRESIDENT

OFFICERS OF THE SAN JOSE AFRO-AMERICAN LEAGUE

Pictured are the officers of the San Jose Afro-American League—Chas H. Overton, secretary; Jacob E. Overton, president; William H. Davis, husband of Harriet Davis; and William Whiting, vice president. This organization was influential with the black voters of Santa Clara County. (Courtesy of Jean Libby.)

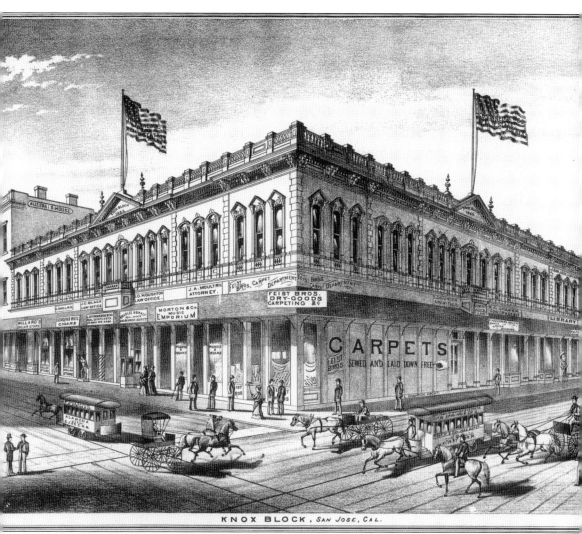

KNOX BLOCK, San Jose, Cal.

Jacob and Sarah Overton were highly respected in San Jose. Jacob, a slave from Kentucky, was born in 1845. As a youth, he traveled to San Jose with Dr. C.J. Overton and was freed after the Civil War. In 1867, after the death of his employer, Dr. Knox, Overton became the janitor at the Knox Block (pictured), considered the best office building in town, and worked there for over 50 years, according to the *Mercury News* column "When San Jose Was Young." Sarah Massey, Overton's wife, was born free in 1851 in Massachusetts and traveled to Gilroy with her family. She attended Cassey's St. Phillip's Mission. In 1869, at the age of 19, she married 24-year-old Jacob Overton at Trinity Episcopal Church. By 1890, Sarah and Jacob Overton operated a successful catering business. Sarah died in San Jose in 1914, and Jacob died in 1922. They had two children, Harriet and Charles, a photographer, and are buried at the family plot at Oak Hill Cemetery in San Jose. (Courtesy of San Jose Public Library.)

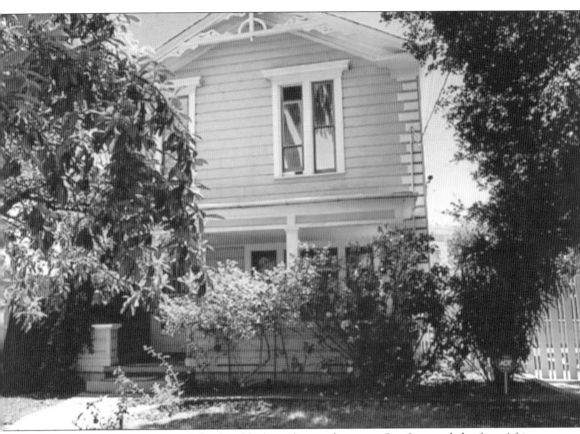

Dr. D.W. Boyer was one of the first black professional men in San Jose and the first African American medical doctor in San Jose. However, he could not practice medicine, so he established a well-respected massage parlor in the Porter-Stock Building at 85 South First Street. The Boyers lived at 446 North Fifth Street (pictured). Elizabeth Boyer, wife of Dr. Boyer, was the founder of San Jose's Garden City Women's Club in 1895. They and other family members are buried at Oak Hill Cemetery. (Courtesy of Jan Adkins.)

Mary Edmonia Lewis, a sculptor born in 1845, was educated at Oberlin College in Ohio. She was the first African American sculptor to achieve international distinction. In 1873, she was invited by the City of San Jose to bring her three unsold works for exhibit. They were shown at the City Market Hall. In December 1873, her work *Lincoln* (below) was purchased as a gift to the San Jose Public Library. The work of Edmonia Lewis is on exhibit in the California Room of the Dr. Martin Luther King Jr. Library. (Right, courtesy of Smithsonian National Portrait Gallery; below, courtesy of Dr. Martin Luther King Jr. Library.)

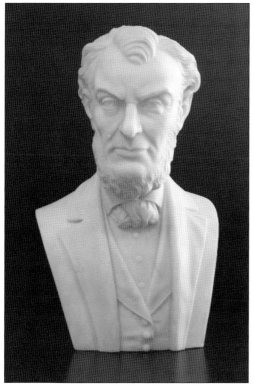

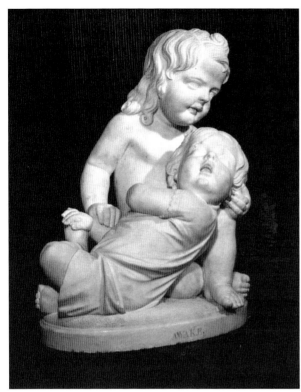

Two other Edmonia Lewis pieces, *Awake* and *Asleep*, were purchased by Sarah Knox-Goodrich, the organizer of San Jose's first Women's Suffrage Association. According to the *Mercury News*, the sculptures were purchased because of Jacob Overton's dedication to the Knox family. In 1914, the sculptures were donated to the San Jose Public Library, where they are on exhibit today. On February 3, 1991, the San Jose chapter of the Links Inc. and the San Jose Public Library System honored the work of Edmonia Lewis as the first African American sculptor. (Both, courtesy of Dr. Martin Luther King Jr. Library.)

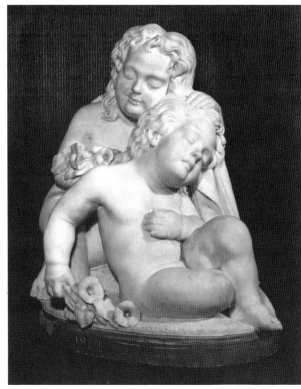

Two

ESTABLISHING COMMUNITY THROUGH THE AFRICAN AMERICAN CHURCH

1860–1945

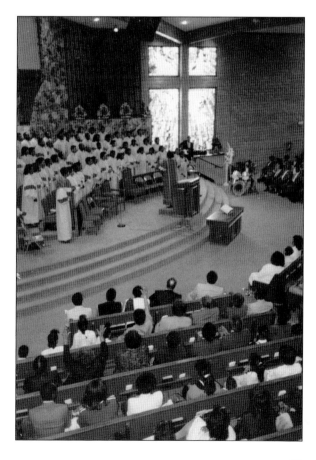

In 1860, a total of 87 people of African ancestry lived in Santa Clara County. By 1870, the number of black residents had increased to 173. By 1900, the number increased to 251. This steady growth is consistent throughout major cities in California. As the number of black citizens increased, the establishment of black churches was needed to address the social, economic, and spiritual needs of the small communities. The Emmanual Baptist Church choir and congregation are pictured here. (Courtesy of Francine Bellison.)

In 1863, members of San Jose's small black community founded First African Methodist Episcopal Zion Church. The 1870 San Jose city directory listed First AME Zion Church at Fourth and San Antonio Streets, on property donated by John Madden. According to *History of African Americans in Santa Clara Valley*, a group of eight people organized the church for the city's black community during the Civil War. This group included William Smith, John Madden, James Lodge, and the original board of trustees. The city directory notes First AME Zion as "the only religious organization among the colored people of the city" and describes the church as in "prosperous condition" and Sunday attendance as "sufficient to fill the church." Reverend A. Stephens was listed as the pastor in the 1870s. According to church history, the original church structure had been shipped from Sacramento by both water and land. The congregation worshipped for 90 years at Fourth and San Antonio Streets. In 1969, the city's urban renewal project forced the church to relocate to 95 South Twentieth Street. First AME Zion Church founders John Madden and his wife, Charlotte, are buried in the Oakhill Cemetery. (Courtesy of Forrest Williams.)

The NAACP was organized in the basement of First AME Zion Church, and the Congress of Racial Equality used the church during the civil rights era as a base for its struggle for equality. Rev. Jethro Moore is standing to the right of church trustee and former city council member Forrest Williams. On this occasion, the church was celebrating its 150th anniversary. (Courtesy of Forrest Williams.)

This plaque was given to First AME Zion Church by the San Jose Chamber of Commerce in celebration its 100 year anniversary. (Courtesy of Forrest Williams.)

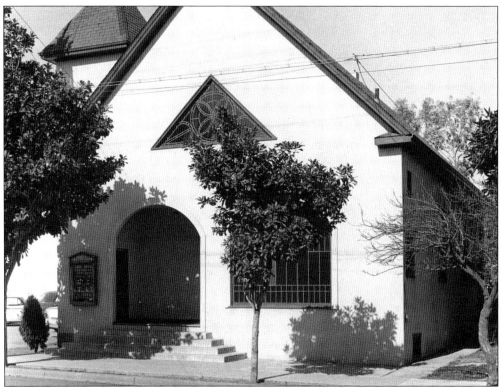

In 1918, University African Methodist Episcopal Zion Church was founded in Palo Alto in the home of Melvina McCaw at 330 Cowper Street. Today, it is the oldest African church in Palo Alto. A small community of people first met and worshipped downtown at Fraternal Hall on High Street. University AME Zion Church provided a place for African American migrant workers from both agricultural and university communities to gather and worship. In 1923, members, along with other community groups, raised money to purchase the property at 819 Ramona Street. This property is listed on the California Register of Historical Resources. The mortgage was burned on July 8, 1939. On July 4, 1965, the ground-breaking ceremony was held at 3549 Middlefield Road in Palo Alto to begin building the present church structure (below). (Both, courtesy of Palo Alto Historical Association.)

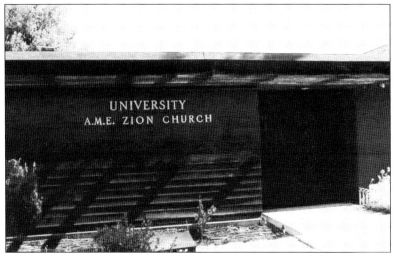

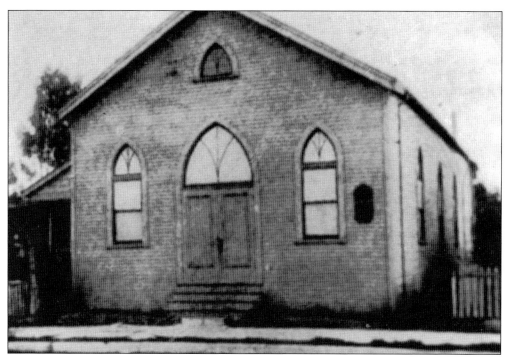

According to *Antioch: A Place of Christians, Chronicles of an African-American Church, 1893–1993,* by Dr. Harriett Arnold, Antioch Baptist Church was organized on August 2, 1893, in the home of Henry and Ellen Hawkins. Rev. Cyclades C. Laws became the first pastor and served from 1893 to 1895. The first church was built at Sixth and Julian Streets and could accommodate 40 worshippers. In 1908, after the earthquake of 1906, a new structure was built to accommodate 150 worshippers at the Julian Street location. The neighborhood surrounding Antioch was known as the "Tar Flats" and named after a rampantly growing, smelly tarweed plant. African American families lived in the north-side neighborhoods surrounding Julian Street, near Antioch Baptist Church. This was the original black community in the area. Given a change in housing policies, by the 1970s African Americans began to spread out and move to neighborhoods in San Jose and other cities of Santa Clara County. (Above, courtesy of Oakland African American Museum and Library; below, courtesy of Charles Alexander.)

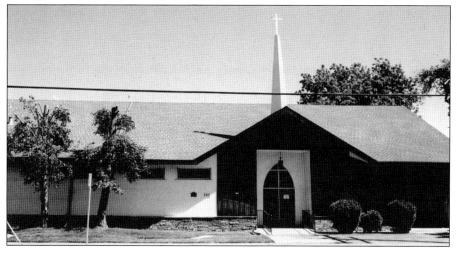

Dr. M. Samuel Pinkston came to San Jose in 1970 and served as pastor of Antioch Baptist Church from 1974 to 1988. Dr. Pinkston was also an adjunct professor at San Jose State University in the Sociology and Black Studies Departments, and taught divinity courses at San Jose Christian College. Reverend Pinkston was active in many community projects in San Jose. He was appointed by Mayor Janet Hays to serve on the committee to establish the African American Service Center. He is remembered as a great optimist. His son Steven Pinkston was a member of his ministerial team. Pictured here from left to right are Rev. Steve A. Pinkston, Dr. Caroll Broadfoot Jr., Dr. M. Samuel Pinkston, and Rev. Herman Kemp. (Courtesy of Pinkston family.)

Prayer Garden, a Pentecostal church, was established in 1943 by Bishop Milton Mathis and his wife, Sister Ruby Mathis, at 651 North Sixth Street in San Jose. Prayer Garden was started with seven to eight members and $200. By 1954, it had grown to about 60 members and a building fund had been started, according to *History of Black Americans in Santa Clara Valley*. Over the years, Bishop Mathis organized a jail ministry for inmates at Elwood Correctional Facility in Milpitas. His church fed the needy, distributed clothes, and provided guidance to youth. Today, Prayer Garden attracts members from throughout the Bay Area. Bishop Mathis died in 1985. (Both, courtesy of Jan Adkins.)

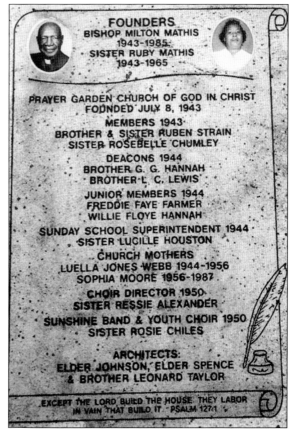

FOUNDERS
BISHOP MILTON MATHIS
1943-1985
SISTER RUBY MATHIS
1943-1965

PRAYER GARDEN CHURCH OF GOD IN CHRIST
FOUNDED JULY 8, 1943

MEMBERS 1943
BROTHER & SISTER RUBEN STRAIN
SISTER ROSEBELLE CHUMLEY

DEACONS 1944
BROTHER G. G. HANNAH
BROTHER L. C. LEWIS

JUNIOR MEMBERS 1944
FREDDIE FAYE FARMER
WILLIE FLOYE HANNAH

SUNDAY SCHOOL SUPERINTENDENT 1944
SISTER LUCILLE HOUSTON

CHURCH MOTHERS
LUELLA JONES WEBB 1944-1956
SOPHIA MOORE 1956-1987

CHOIR DIRECTOR 1950
SISTER RESSIE ALEXANDER

SUNSHINE BAND & YOUTH CHOIR 1950
SISTER ROSIE CHILES

ARCHITECTS:
ELDER JOHNSON, ELDER SPENCE
& BROTHER LEONARD TAYLOR

EXCEPT THE LORD BUILD THE HOUSE THEY LABOR
IN VAIN THAT BUILD IT - PSALM 127:1

Emmanuel Baptist Church was founded in 1965 in the home of Brother and Sister Mayes in Milpitas and was incorporated in 1966. Since the 1970s, Emmanuel Baptist Church has been located at 467 North White Road in San Jose. For the past several years, through the Youth Minister and Family Life Center, Emmanuel Baptist Church has offered writing skills workshops and math workshops, serving students from its church community and the surrounding neighborhoods throughout the school year. The many tutors, mentors, and instructional volunteers are experienced educators, scientists, mathematicians, and language arts specialists who assist students. The photograph below shows a drill team performance, one of the many youth programs sponsored by Emmanuel Baptist Church. (Both, courtesy of Francine Bellison.)

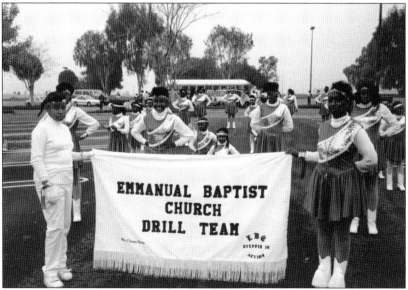

Three

20TH CENTURY AFRICAN AMERICANS AND COMMUNITY BUILDING

1900–1950

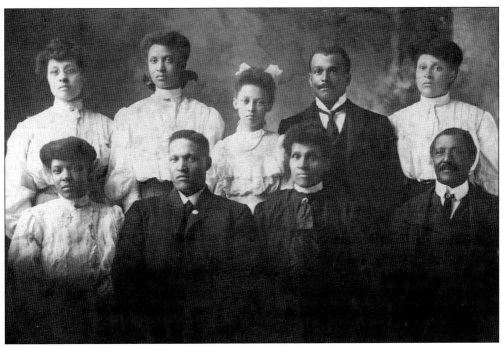

By 1900, two hundred fifty-one African Americans lived in Santa Clara County, while the county population had reached 60,216. Most of the early black families lived in North San Jose. In Palo Alto, the early black community started near Fulton and Cowper Streets. Many African Americans came from Oklahoma and the South during the wave of the great migration, seeking greater opportunities and acceptance. Pictured in this Horton family photograph are, from left to right, (first row) Mary, James, Malinda Little Horton, and William R. Horton; (second row) Adeline, Carrie La Norma, Dortha, Hugh Gwyn, and Martha Horton Gwyn. (Courtesy of Sourisseau Academy, San Jose State University, Department of History.)

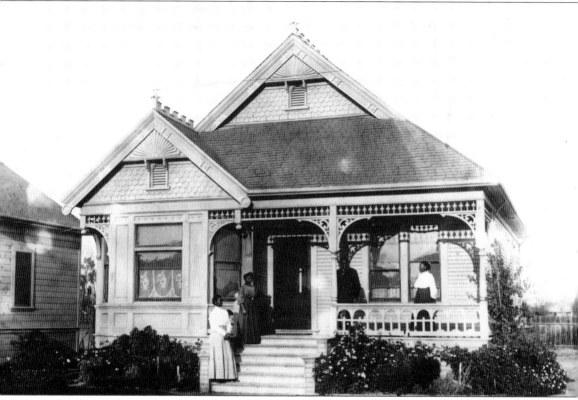

John B. and Annie V. McCall and family lived at 386 North Twelfth Street in 1910. The home was occupied by a McCall until John died in the 1960s. According to Herbert Ruffin, the NAACP was founded on February 8, 1942, in the McCalls' home. At the time, the organization had 103 paying members. Annie was a member of the Garden City Women's Club, the oldest black women's club in California. John worked as a custodian at San Jose Water Works. Annie preceded John in death, and when John died, he left his property to Phillip Ellington and his family. (Courtesy of Phyllis Ellington.)

John W. Jordan, born in 1871 in Pennsylvania, and Rosalind Guess Jordan, born in 1877 in California, married in 1896. The Jordan family moved to 468 North 11th Street in 1909 and raised six children, who attended Grant Elementary School, Roosevelt Middle School, and San Jose High School. John was listed in 1893 as a founder of the Antioch Baptist Church according to Antioch, A Place of Christians. Soon after moving to San Jose into their house on Fifth and Empire Streets, he became a waiter at the Vendome Hotel. At age 29, he worked as a station porter as well. Their house is still owned by family members today. (Both, courtesy of Robert Ellington.)

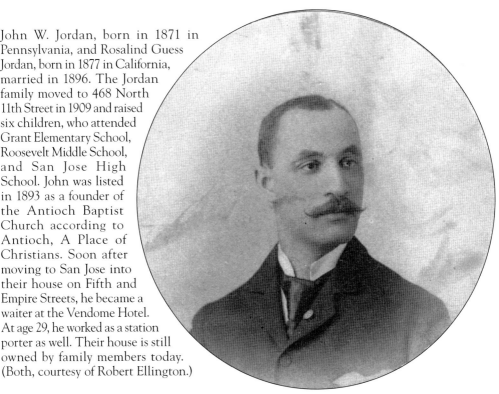

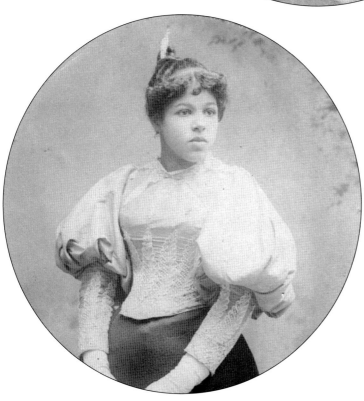

According to an 1896 *Evening News* article, Maud Frances Arques and Dr. Frasse married on September 8, 1896, at the Vendome Hotel in San Jose. An article in the *Mercury News* on Sunday, February 15, 1987, stated that John Jordan, a waiter at the hotel, is standing in the background. (Courtesy of History San Jose.)

Joyce Bernice Jordan Ellington, standing second from left, is the granddaughter of John and Rosalind Jordan. She is pictured above with her mother, Bernice M. Jordan (seated in front of her), sisters, and other family and friends. This photograph was taken in the 1930s in the backyard at the Jordan house at 468 North Eleventh Street, pictured below. Later, the Jordan home became Joyce and Robert Ellington's property. (Both, courtesy of Robert Ellington.)

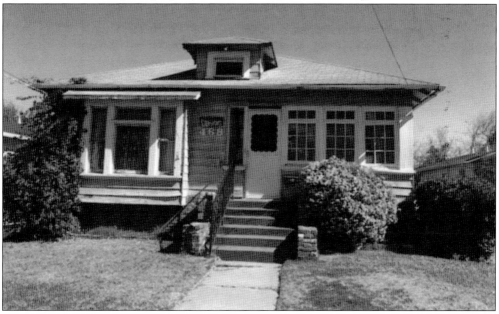

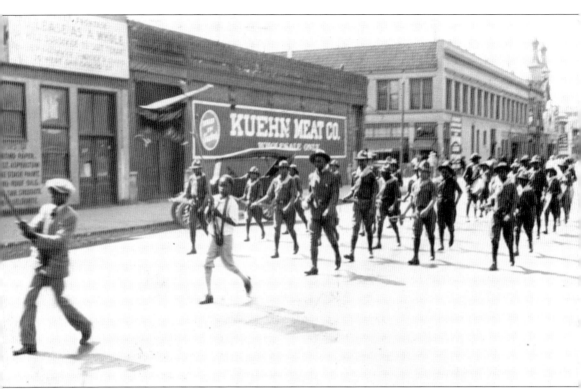

In 1900, nine African Americans lived in Palo Alto. Five were Harris family members, and two were McCaws. They were porters, bricklayers, bootblacks, domestics, laborers, gardeners, and small business owners. Many African Americans were employed by Stanford University as domestics and laborers. By the 1920s, many African Americans lived on Fife Avenue, which was historically a black/minority street where restrictive covenants did not exist. It is believed that Southern Pacific Railroad porters may have lived in housing on Fife Avenue, and opportunities for domestic work may have existed in nearby communities. This is a photograph of Boys Scouts marching in Palo Alto. (Courtesy of Sourisseau Academy, San Jose State University, History Department.)

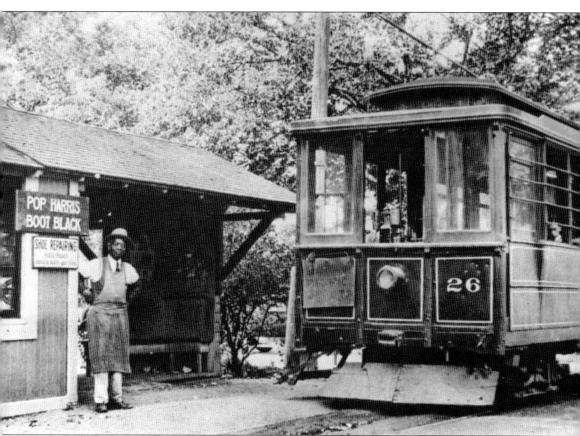

Seaman Harris stands in front of his bootblack shop on the Stanford campus. Known as "Pop Harris," he was born in slavery in 1852 but later escaped and settled in Palo Alto in 1892. In 1896, Harris bought a house on Fulton Street and sent for his family. The census of 1900 lists him, his wife Amanda, and son Lloyd living on Fulton Street. Prior to the 1920s, many black residents lived in neighborhoods along Ramona, Homer, Channing, Bryant, Cowper, and Fulton Streets. (Courtesy of Palo Alto Historical Association.)

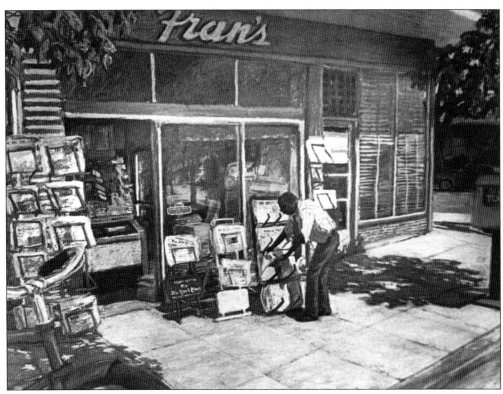

After World War II, Harris's son Fran (Mac) Harris opened Fran's Market at Lytton Avenue and Cowper Street. He attended high school in Palo Alto. (Courtesy of Palo Alto Historical Association.)

Sam McDonald was born in Louisiana in 1884 and moved to California in the 1890s. In his 1954 autobiography, *Sam McDonald's Farm*, he tells of his life as a young boy working on a farm in Gilroy with his father and brother, relocating to Sacramento, and traveling to Washington. In 1903, McDonald moved to Mayfield (South Palo Alto) and began working for Stanford University at the stock farm. He also served as deputy constable for Palo Alto Township and deputy sheriff for Santa Clara County. In 1954, he retired from Stanford as superintendent of buildings and grounds. His pet project was the Stanford Convalescent Home for Underprivileged Children, where he planted gardens and cooked barbecues. The home was named in his honor. McDonald also began acquiring La Honda property along Alpine Creek in 1917. When he died in 1957, he left his La Honda property (400-plus acres) to Stanford with a request to use the land as a park. In 1958, San Mateo County acquired the land for $67,000 and dedicated it for public use in 1970. It is known today as Sam McDonald Park. (Courtesy of Palo Alto Historical Association.)

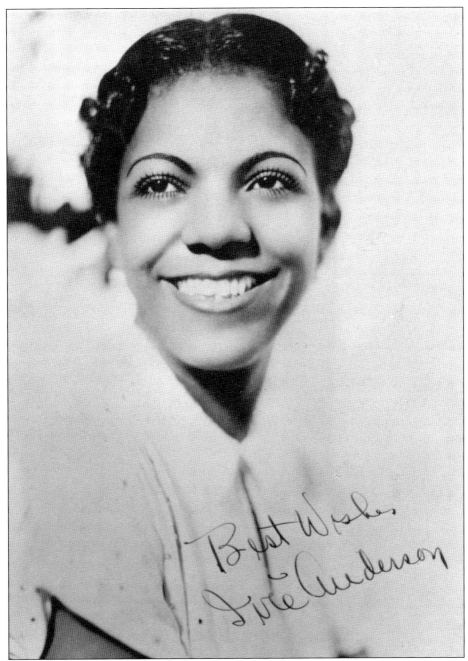

Ivie Marie Anderson, born in 1903, lived in Gilroy from 1903 to 1917. At 14, she left Gilroy High School and went to the Nannie Burroughs School for Girls, a finishing school for black girls in Washington, DC, where she received an education and vocal training to pursue her musical career. For the next 10 years, she studied voice and performed in Los Angeles at various venues. She starred in the hit musical *Shuffle Along*, and toured Europe in a revue with musical comedy star Florence Mills. In 1930, Ivie Anderson was noticed by Duke Ellington's father in Chicago. She was invited to sign with Ellington and performed with him for the next 12 years. (Courtesy of Gilroy Historical Museum.)

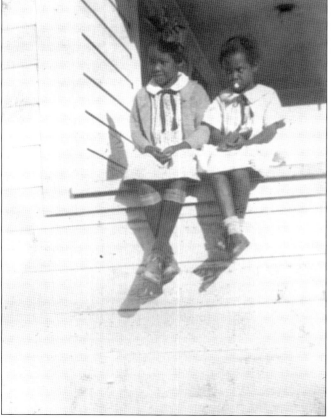

Ivie Marie Anderson lived with her mother, stepfather, and sister in the house at 363 Old Gilroy Street in Gilroy. She is seated at right in the image at left. She attended St. Mary's Elementary School in Gilroy, where her musical talents were recognized at a young age. While in school, she received vocal lessons and sang in the school's glee club. (Both, courtesy of Dave Porcella.)

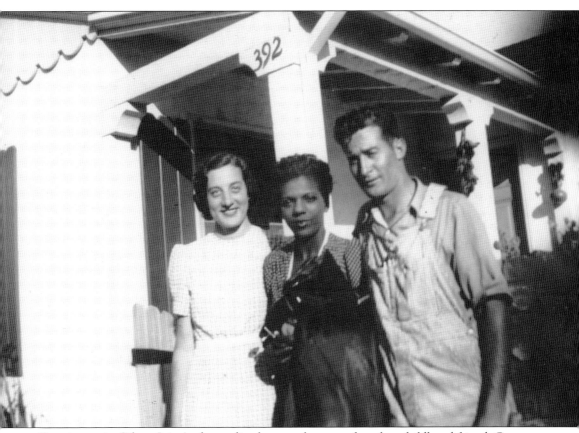

Growing up in Gilroy, Ivie Anderson lived across the street from her childhood friend, George Porcella. After leaving at 14, she returned to Gilroy to visit. This photograph shows, from left to right, Ann Porcella, Ivie Anderson, and George Porcella in front of the Porcella family home at 392 Old Gilroy Street. (Courtesy of Dave Porcella.)

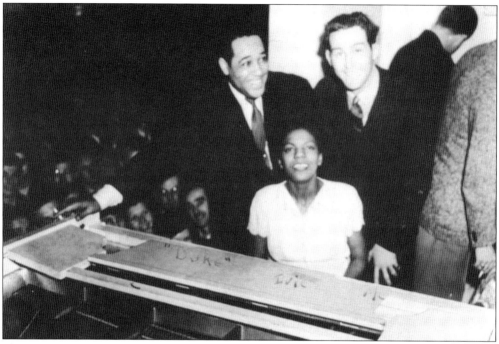

Shown above, Ivie Anderson is seated with Duke Ellington and George Porcella standing behind her. Anderson performed with the Duke Ellington group for 12 years. She was the first black singer to become a permanent member of a black orchestra. According to local historian Phill Laursen, her first recording was "It Don't Mean a Thing if it Ain't Got that Swing." In the 1930s, Anderson toured Europe with Duke Ellington's orchestra and performed before the Duke of Windsor. She starred in several musicals throughout her career. Below, she is pictured with, from left to right, George Porcella, musician Ben "Shadrack" Carter, and musician Bill Harris at Sweet's Ball Room in Oakland, California, in the 1930s. (Both, courtesy of Dave Porcella.)

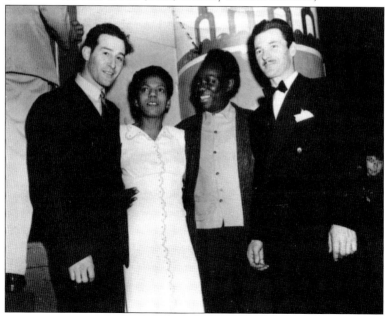

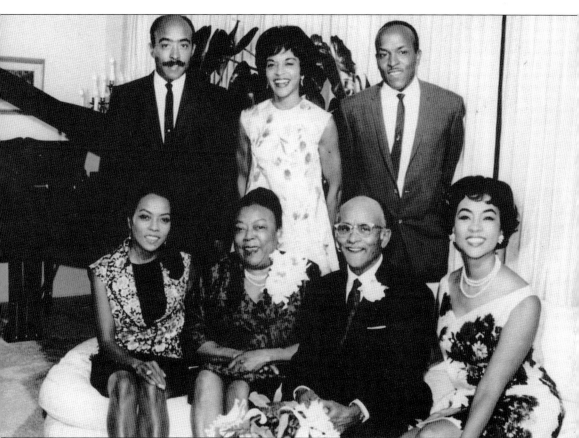

Henry and Nora Ribbs were born in Louisiana during the late 1890s and established their home in San Jose in 1922. The family story published in *What's In a Name* tells the harrowing tale of how William Henry Beck (Ribbs) and his brother Clyde left Louisiana in search of a safe place to move their families. According to Heather Ribbs, Henry Ribbs met Theodore Moss, a local black plumbing contractor, who taught him the plumbing business. In 1927, Henry opened Ribbs Plumbing on the corner of Alum Rock Avenue and Jackson Street. In the 1960s, Henry retired and his sons William Theodore (Bunny) and Felix Ribbs continued the family business. From 1968 into the 2000s, Felix and Bunny shared the business, each running his own part of the company. According to the family story, Henry and Nora "believed in the virtues of hard work and taught their children that if a thing was possible to be done, each of them was expected to learn how." Henry died in 1996. This photograph shows Henry and Nora celebrating their 50th wedding anniversary with their five children. From left to right are (seated) Evelyn, Nora, Henry, and Alma; (standing) Bunny, Juanita, and Felix. (Courtesy of History San Jose.)

Both Henry Ribbs and his brother Clyde Ribbs, who had also left Louisiana, established businesses in San Jose. According to an interview for the Garden City Women's Club, Clyde and Ola Ribbs came to San Jose in 1919 and bought the Jones Transfer Company from Mildred Jones; it was established in 1906. Under the ownership of Clyde, Jones Transfer Company became one of the first black-owned businesses in San Jose. In this same interview, it was stated that Henry Ribbs was known for standing up for what was right. For example, he tells the story of when his son Bunny and a Japanese schoolmate attended a school picnic at Alum Rock Park and were told they could not swim in the pool with the other children because of their race. Upon hearing this, Henry found the mayor and took him to the park to speak to the pool attendant. From then on, the boys were allowed to swim. The mayor, Clarence Goodwin, stated, "All kids can go into that swimming pool." William T. (Bunny) Ribbs's son Willy T. was a professional race car driver at one time. Ribbs Lane, named for Henry Ribbs in the 1960s, is located off Alum Rock Avenue between Jackson Street and Foss Avenue in San Jose near the family business. (Courtesy of History San Jose.)

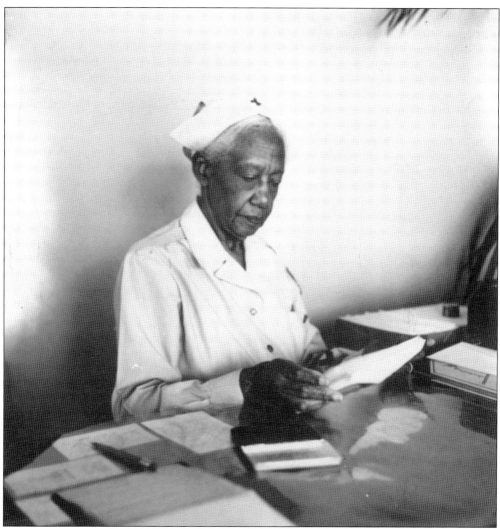

Lucy Turner Johnson, a member of Antioch Baptist Church, was the first African American to graduate from the California State Normal School at San Jose, known today as San Jose State University, in 1906. The California State Normal School was a teaching college founded on May 2, 1862. Johnson graduated as a teacher in the spring of 1906. She was a friend of the McCall family of San Jose. The census of 1900 indicates that Johnson lived with her parents and three sisters on Julian Street. In later years, she relocated to Oakland. (Courtesy of Oakland African American Museum and Library.)

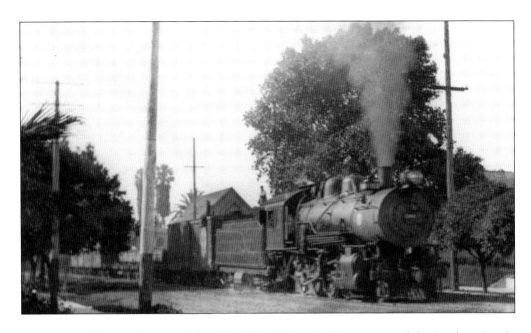

According to *Blacks in Palo Alto*, before World War II, Stanford University and the Southern Pacific Railroad were the major employers of African Americans. Many worked as porters or redcaps for Southern Pacific on trains that ran from San Francisco to Monterey. Many rented property in Mayfield. Those employed at Stanford worked as janitors or in the laundry. In the 1920s, there were more than 80 black residents in Palo Alto. Housing discrimination was the major problem facing them before World War II. Housing covenants were established to channel minority populations to the older neighborhoods of Palo Alto. Pictured above is a Southern Pacific train; below is the railroad station at Santa Clara. (Both, courtesy of History San Jose.)

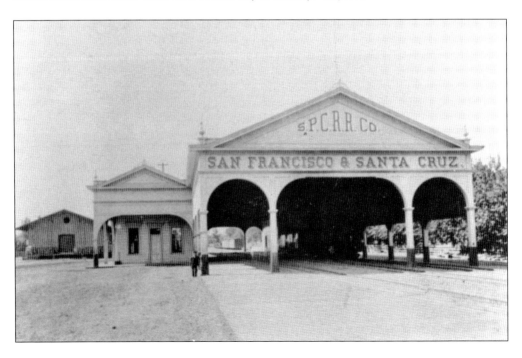

Four

THE GOOD BROTHERS, EDUCATIONAL OPPORTUNITIES, AND BLACK STUDENT ATHLETES

1950–1968

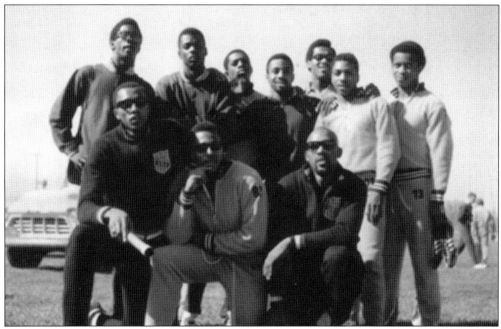

In 1950, Santa Clara County's population reached 290,547, while the black population reached 1,718. By 1970, the county's population reached 1,064,714, and the black population reached 18,090 (1.7 percent). Between 1950 and 1970, San Jose State College recruited very few black students who were not athletes, and those athletes struggled to overcome racism and discrimination to accomplish their education goals. Today, African American students average about three percent of the student population. This photograph, taken by Jeff Kroot, shows the "Speed City" team in 1968. From left to right are (first row) L. Tommie Smith, Ronnie Ray Smith, and John Carlos; (second row) Kirk Clayton, Jerry Williams, Sam Davis, Bill Gains Lee Evans, Bob Griffin, and Frank Slayton. (Courtesy of Urla Hill.)

San Jose State began recruiting African American student athletes in the mid-1950s. Many came from small towns in central California and were outstanding athletes in either football or track and field. About 35 black student athletes were recruited in the 1950s. They were often recruited as a group and were able to assist each other to meet their athletic and academic goals. According to Herbert Ruffin's *Uninvited Neighbors*, these athletes used sports to gain a college education and together understood their common daily struggles against racism. They uplifted each other and advocated for each other's success, both educationally and professionally. Given the discrimination in San Jose, finding housing for San Jose State College's African American athletes was a problem. The photograph shows the Good Brothers' Pad (house), which provided housing for black athletes, on Fifth and St. Johns Streets. (Courtesy of History San Jose.)

Before 1968, black student athletes found it very difficult to find housing, given discriminatory housing practices in San Jose. Many black athletes could not get housing around the campus. In 1956, some of the student athletes were housed in equipment sheds until better housing was found. Charles Alexander, a student athlete, established the Good Brothers' Pad, which provided housing for black student athletes. Together, the students living at the house paid the rent. According to Charles Alexander, some had to work odd jobs, such as cleaning chicken coops, when not in school or practicing their sport. Many students slept wherever they could find a spot. No one was turned away. Sitting on the step is Charles Alexander's father, David Alexander, who prepared meals at the house for the athletes. In the 1950s, black athletes were often excluded from social events on campus and could not patronize entertainment venues in San Jose, so the Good Brothers' house also became a place to hold social events where people of racially diverse backgrounds could intermingle. (Courtesy of History San Jose.)

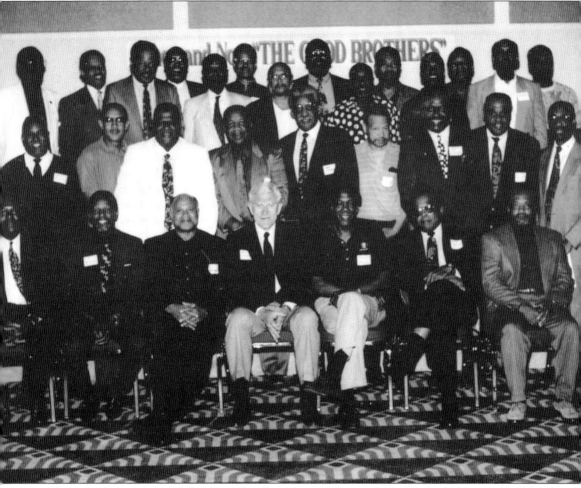

Here are the residents of the Good Brothers' house 50 years later. In the 1950s, many of the student athletes did not challenge the athletic department about discrimination and its treatment of black athletes, although many felt like they had been exploited by the college. According to Charles Alexander, all graduated and established careers as doctors, judges, lawyers, dentists, coaches, administrators, and other professions. They had to overcome many struggles as student athletes and first-generation college students. These men opened many doors for not only student athletes following in their footsteps, but for other African American students seeking a college education. From left to right are (first row) Jim Long, Chuck Alexander, Joe Barrington, Coach Bob Bronson, Charly Hardy, Herb Boyel, and Mel Newton; (second row) Herb Michlley, Don Smith, Mel Powel, George Cobb, Jack Crawford, Al Connly, Mel Powell, Ed Hughs, and Archie Carter; (third row) unidentified, Tom Broome, Ed Black, Joe Wyrick, unidentified, Clint Dedus, Oniel Catery, Charles Fikes, Dave Brown, Cass Jackson, Bob Pointer, and Ed Haygood. (Courtesy of Charles Alexander.)

Charles Alexander attended San Jose State College (SJSC) in 1955 on a football scholarship. He was one of 10 black athletes recruited in 1955 by the SJSC athletic department. Alexander ran the Good Brothers' Pad from 1955 to 1962. After graduating from SJSC in 1962, he began working in juvenile corrections in 1960, starting as a counselor, then supervisor, then assistant superintendent. Eventually, he became the superintendent of the Boys Ranch in San Jose. Since his retirement in 1985, Alexander has worked as a photographer. In 1959, he married Saphran, the first African American telephone operator with Bell Systems. (Both, courtesy of Charles Alexander.)

Dr. Harry Edwards's influence on athletes and athletic programs throughout colleges and universities is still evident today. Edwards dreamed of going to the Olympics. In 1961, he transferred from Fresno City College to San Jose State College. At six feet, eight inches tall and 250 pounds, he participated in four sports—track and field, football, basketball, and baseball. Edwards criticized the way black student athletes had to compete against each other for an available scholarship. When he verbally expressed his concerns to Coach Bud Winter, he lost his own scholarship; it was given to another black student athlete. Edwards was able to speak out since he could continue his education on a basketball scholarship. This was the beginning of his activism against the treatment of the black athlete, and Edwards began to organize protests and demonstrations to address the injustice toward black student athletes at white universities. He also held study hall sessions with black athletes for tutoring and to help them complete their coursework. (Courtesy of Harry Edwards.)

Dr. Edwards was concerned about the failure of black student athletes to graduate within the period of their scholarships. Black students had to deal with restrictive housing practices off campus, and on-campus housing was only available if a black student could find another black student to live with. Academically, black students were funneled into easy curricula like physical education as opposed to math, science, and the humanities. After graduating in 1964, Edwards went to Cornell University, where he earned his master of arts degree. He returned to San Jose State College from 1966 to 1968 as a lecturer while writing his dissertation on the sociology of sports. Between 1966 and 1968, more black male athletes were recruited to run track and play football, which began the Speed City legacy. Edwards felt black student athletes were the most exploited students on campus, and he organized a movement to address institutional racism and exploitation. He became a leader in the United Black Students for Action movement that addressed issues faced on college campuses, challenged systems for social justice and human rights, and pushed for the creation of diversity programs. (Both, courtesy of Harry Edwards.)

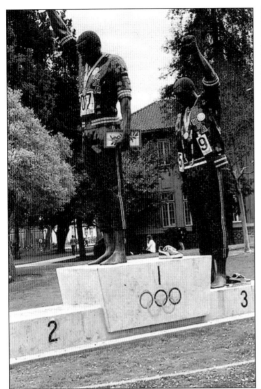
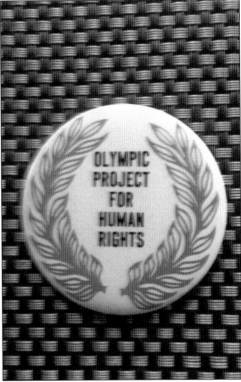

The demonstration by Tommy Smith and John Carlos at the 1968 Olympics in Mexico was the culminating protest over the plight of the black athlete in America. In 1967, Edwards's Olympic Project for Human Rights challenged the US Olympic Committee. Black athletes in track and field, basketball, and football from various colleges and professional athletes such as Jim Brown and Muhammad Ali supported the revolt. Instead of boycotting the Olympics, they decided to protest individually. During the award ceremony after winning the gold medal, Tommy Smith, along with John Carlos, who won the bronze in the 200-meter race, protested in a way that shocked the world. Both men stepped onto the podium in black socks, shoeless, to signify African American poverty in the United States, and with eyes closed and head bowed, they raised their black gloved fist in a sign of black unity and power. Carlos and Smith were expelled from the Olympics. Today, changes have been made in professional sports, from hiring practices, to the creation of NFL internship programs for promising black coaches, to ESPN football analyst opportunities. SJSU's population has also changed. By 1980, the once 90 percent white student body in the 1960s evolved into a university with a diverse curriculum and faculty. Today, the statue of Tommy Smith and John Carlos pictured at left can be found on the campus of San Jose State University. The Olympic Project for Human Rights pin on the right was worn on the uniform of John Carlos and Tommy Smith. (Left, courtesy of Urla Hill; right, courtesy of Dr. Harry Edwards.)

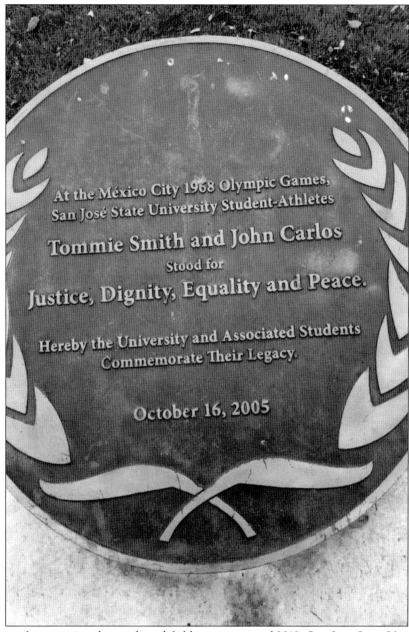

At the México City 1968 Olympic Games,
San José State University Student-Athletes

Tommie Smith and John Carlos

Stood for

Justice, Dignity, Equality and Peace.

Hereby the University and Associated Students
Commemorate Their Legacy.

October 16, 2005

Fifty years after stopping the track and field program, as of 2018, San Jose State University is resurrecting it men's track program. The Spartans will attempt to recreate its famous Speed City team. Recently, John Carlos has said, at the time of the protest, they chose to speak for those who did not have a voice. A bronze statue of John Carlos and Tommy Smith at the 1968 Olympic awards podium is in the National Museum of African American History and Culture in Washington, DC. Today, John Carlos, Tommy Smith, Dr. Harry Edwards, and many professional athletes have accepted the mission to reach out to middle and high school students and encourage them to strive for their dreams and help change society. The plaque shown here honoring the demonstration at the 1968 Olympics has been placed near the statues of Tommy Smith and John Carlos. (Courtesy of Harry Edwards.)

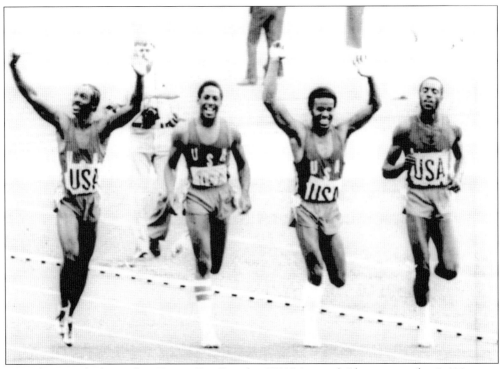

This photograph shows the "Fastest Four" at the 1976 Montreal Olympics in the 4x100 meter relay as the team takes its victory lap. From left to right are Harvey Glance, John Jones, Millard Hampton, and Steven Riddick. Hampton was from San Jose; after the Olympics, he became a distinguished San Jose police officer. (Courtesy of History San Jose.)

In 1966, Robert Griffin of Richmond, California, ran the 100, 220, 4x100, and 4x200 events for San Jose State College. He earned his bachelor's and master's degrees at SJSC. After graduation, he served as director of student activities from 1971 to 1976. After multiple administrative positions at Bay Area colleges and receiving a PhD in public administration, Dr. Griffin served as vice president of education programs and services at DeAnza College, from 1994 to 2008. For the last 10 years, he has served on the board of San Jose Jazz. (Courtesy of Robert Griffin.)

Five

Postwar Technology Boom and Opportunities for African Americans

1950–1990

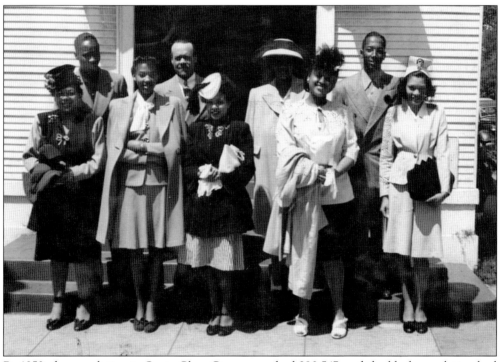

By 1950, the population in Santa Clara County reached 290,547, and the black population had grown to 1,718. By 1960, the African American population reached 4,187 due to the establishment of Milpitas and other employment opportunities. This trend continued through the 1990s, when the black population reached 55,365 out of a total population of 1,497,577. The establishment of new technology industries brought new job opportunities to communities in Santa Clara County and attracted black college graduates from across the country. The Ellington family is pictured here in front of Third AME Zion Church in San Jose. (Courtesy of Phyllis Ellington.)

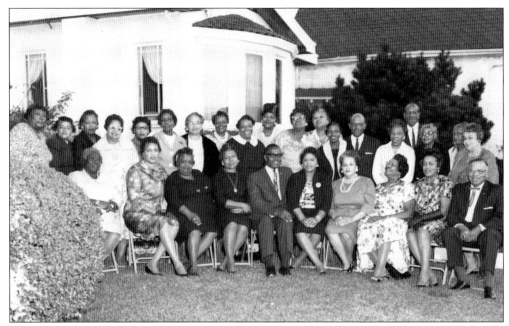

Since the early families of the 1860s, most African Americans lived in north San Jose neighborhoods near downtown, given housing discrimination policies in other parts of the county, but by the 1970s, many African Americans were able to move to other communities throughout the county. In San Jose, many moved to neighborhoods in south San Jose. In Palo Alto, Joseph Eichler, real estate developer, built new homes for middle-class Americans and established a nondiscriminatory policy. With Eichler's policies for diverse neighborhoods, many African Americans moved into places once restricted to white residents. The photograph above, taken in the 1970s, shows many of San Jose's pioneer families. Below is a house in Palo Alto built by Joseph Eichler. (Above, courtesy of Robert Ellington; below, courtesy of Jan Adkins.)

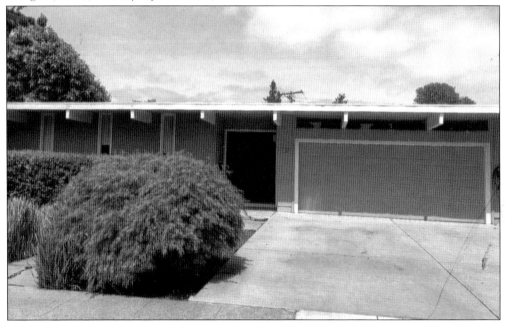

The Ellington family has made the north side of San Jose home since 1917, when Napoleon Ellington, born in 1882, and Bertha Ellington, born in 1890, relocated to San Jose. Napoleon worked as a porter. He and Bertha raised six children, Wesley, Phillip, Robert, Mary, Gloria, and Deloris. The family lived in the Grant Elementary School, Roosevelt Junior High School, and San Jose High School district. Bertha was active in the Negro Cultural Class, a group of black women in San Jose who traced the cultural backgrounds of black women. She was a member of the Garden City Women's Club and president of the Dorrie Miller Chapter of American War Mothers of San Jose. She was known to work for improving the black community as well as her family. Bertha was also active in the Order of the Eastern Star. Napoleon lived until 1944, and Bertha lived until her death in 1982 at the age of 94. The Ellington family attended First AME Zion Church at Fourth and San Antonio Streets. In this 1980s photograph are, from left to right, Robert Ellington, Mary Ellington Tanner, Scottie Ellington (Wesley's son), Gloria Ellington, and Phillip Ellington. (Courtesy of Phyllis Ellington.)

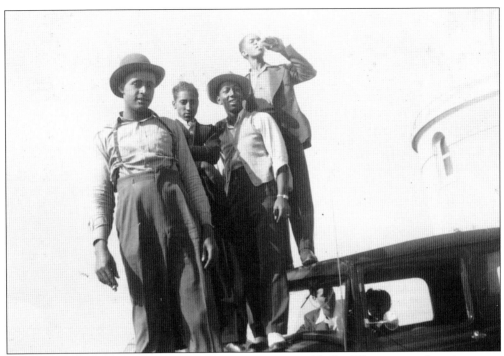

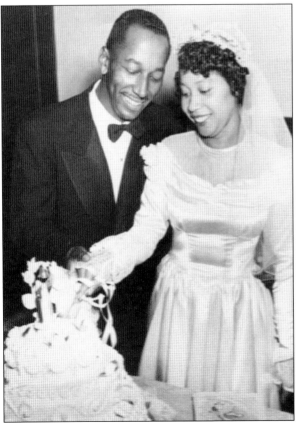

Phillip Ellington was born in San Jose on the north side in 1919. Most black families lived in the Northside neighborhood, and the children attended Grant Elementary, Roosevelt Junior High, and San Jose High School. Phillip Ellington attended San Jose Normal School (San Jose High School), graduating in 1937. He attend San Jose State College after high school before enlisting in the Navy. Here, he is standing on the top of a car with his friends from the neighborhood, second from the right. He died in 2006. (Courtesy of Phyllis Ellington.)

Phillip Napoleon Ellington married Essie Burton in 1952. They had two children, Phyllis and Eva. Both daughters graduated from San Jose High School. Phillip Ellington was nicknamed "Duke." According to family members, Duke Ellington the musician was a cousin to the Ellingtons in San Jose. (Courtesy of Phyllis Ellington.)

Phillip Ellington was one of the first black postmen. He is shown here in his postal uniform receiving an award. In 1947, he joined the US Postal Service as a letter carrier at the St. James office after serving in the Navy. Ellington served 33 years with the post office, retiring in 1978. He received a certificate commemorating his service. While at the post office, Ellington also served as a volunteer police reserve for 22 years with the San Jose Police Department. He was the first African American in the San Jose police reserves. While a volunteer reservist, Ellington was promoted to lieutenant. In 2000, he was elected vice president of the American Bowling Congress of San Jose. At 75, Ellington bowled his first 300 game and golfed his first hole in one from 137 yards in 2003. (Courtesy of Phyllis Ellington.)

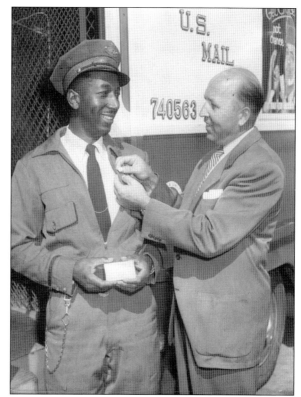

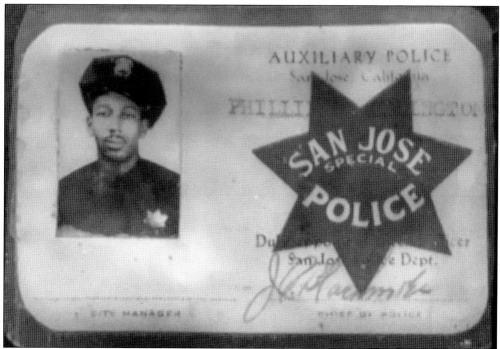

Phillip Ellington served as a volunteer reserve officer with the San Jose Police Department before black officers were hired. (Courtesy of Phyllis Ellington.)

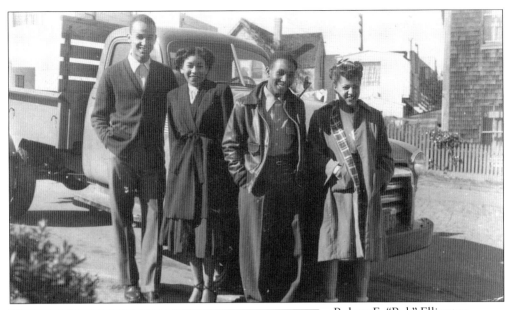

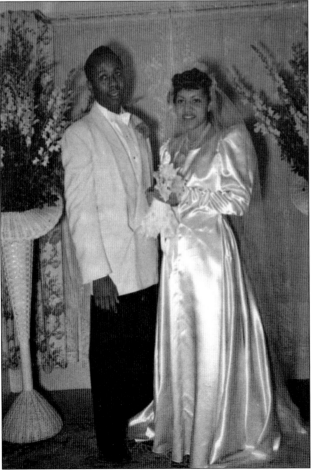

Robert E. "Bob" Ellington, another Ellington brother also nicknamed "Duke," was born in 1923 to Mary Louse (Bertha) and Napoleon Ellington. He graduated from San Jose State College in 1949, and married Beatrice Joyce Jordan, born in 1930, in February 1953 at Antioch Baptist Church. They are pictured at left at their wedding. The Ellington and Jordan families knew each other and enjoyed social activities together. Joyce (far right above) and Robert both attended Grant Elementary School, Roosevelt Junior High, and San Jose High School. Robert, an Army veteran, worked for Pharmaceutical Shipping as a clerk. They raised their five children in San Jose's Northside neighborhood, and they attended local public schools. Robert Ellington volunteered for 60 years with the Boy Scouts of America. (Both, courtesy of Robert Ellington.)

Joyce Ellington served the communities of San Jose for 40 years. She was a graduate of San Jose High School and Evergreen Valley College, where she received her associate's degree at the age of 74. She was a founder of the Northside Neighborhood Association, a member of the Grant Elementary PTA, and a member of the Eastern Star. Joyce advocated for the development of Downtown San Jose and in 1980 served as the first African American chair of the Library Commission. In 2002, Congresswoman Zoe Lofgren recognized Joyce's "extraordinary and tireless service to the residents and members of the Northside Neighborhood Association." Joyce served on the board for 36 years. She lived in the home built by her grandfather, John Jordan, in 1908, which is still in the hands of the Ellington family today. She has the honor of having a public building named after her, the Joyce Ellington Library. Congresswoman Lofgren credits Joyce Ellington for reminding citizens that one person can truly make a difference in the lives of many. In the photograph above, Joyce is speaking to a group of concerned citizens. At right, Bob Ellington distributes food to the poor of North San Jose. (Both, courtesy of Robert Ellington.)

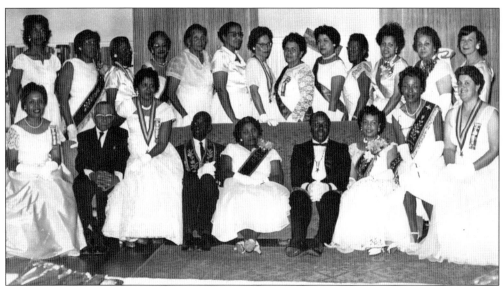

Many black San Jose community leaders joined the Eastern Star and Masons organizations. These photographs, taken in 1964 (top) and 1956, show members at club ceremonies. Above are members of San Jose's Eastern Star. From left to right are (first row) Ruth Ray Aladin, Clyde Ribbs, Rosalie Gibson, Theodore Moss, Inez Jackson, Robert Ellington, Dolly Moore, Albertine Record, and Irene Eckford; (second row) Eleanor Threadgill, Helen Wheeler, Hazel Ferguson, Rosalind Taylor, Bertha Ellington, Mary I. Fisher, Lednora Jordan, Amy Cannon, Roma Lee Woods, Delores Lewis, Joyce Ellington, Bernice Jeffries, and Billy White. The photograph below shows members of the San Jose Free Masons. From left to right are (first row) James Burnett, Jim Calloway, Robert Ellington, Theodore Moss, unidentified, and Alvin Young; (second row) Nathaniel Eckford, Alceed Buchanan, Carl Bard, Arthur King, Bob Waters, Pat Taylor, Nathan Jeffries, Clarence Frazier, and Clyde Ribbs; (third row) Francis Tanner, Wesley Ellington, George Adams, and Charles Davis. (Both, courtesy of Robert Ellington.)

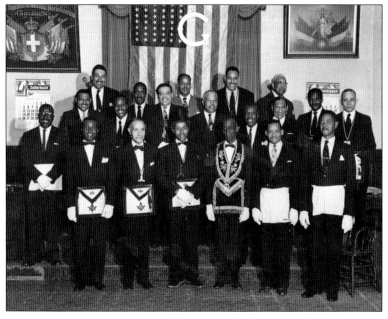

Capt. Samuel L. and Mary Parks Washington moved to Campbell, California, in 1958. He was a pilot with the Tuskegee Airmen, assigned to the 99th squadron of the 332nd Fighter Group based in Italy during World War II. He flew the P-40 Warhawk and P-51 Mustang. In 2007, Captain Washington and his unit received the Congressional Gold Medal. In 2018, the Campbell Veterans Memorial Association named Washington the 2017 Veteran of the Year. Erik (Washington) Tukulan followed in his mother's footsteps as an artist. At 11 years old, he was hired by the *Campbell Press* to create his cartoon strip *Ernie*. After graduating from Campbell High School, he earned a degree from SJSU. Erik traveled the world and pursued a career in film and script writing. He loved track and field and competed in high school. During the 1960s, he encouraged his parents to invite the SJSU track athletes to their home for Sunday dinner. (Courtesy of Mary Parks Washington.)

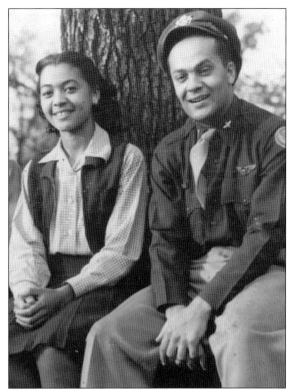

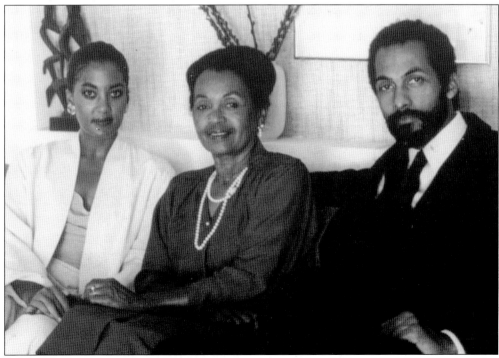

Pictured here are Mary Parks Washington (center) with Jan (left) and Erik Washington after Samuel's death in 1981. (Courtesy of Mary Parks Washington.)

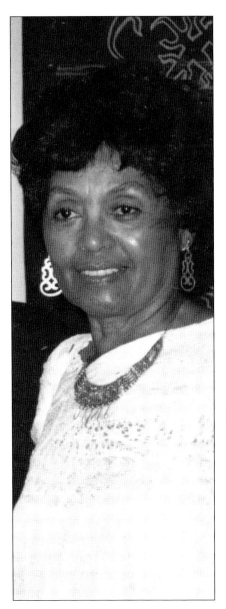

Mary Parks Washington, a renowned artist studying
at the Arts League in New York in 1945, graduated
from Spelman College in 1946 and then attended
Black Mountain College in North Carolina. She
studied with Jacob Lawrence and was mentored
by Hal Woodruff. Mary taught for 28 years in the
San Jose Union District. She received her master's
degree from SJSU. She also started the NAACP
scholarship program for SJSU students. Samuel and
Mary's children, Jan, a Spelman graduate and airline
stewardess, and Erik attended Campbell schools.
Below is an example of Mary Parks Washington's
art. (Both, courtesy of Mary Parks Washington.)

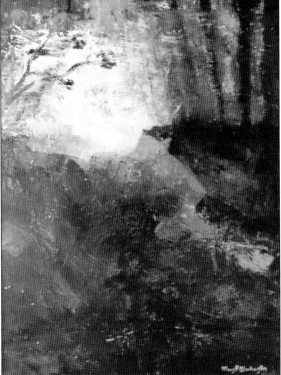

Oreese and Joyce Elmore came to San Jose in 1963 from San Francisco, looking for a home to purchase. In 1960, Oreese was employed by San Francisco International Airport as an operations coordinator; eventually, he became deputy director of the airport. Joyce, after completing her master's degree and education credentials from San Jose State University, began working at James Lick High School. She was very active developing African American dance performances with high school students from throughout the district for Black History Week presentations. Before retirement, Joyce volunteered extensively to provide cultural events and activities throughout the school districts in Santa Clara County. Both Oreese and Joyce devoted over 20 years to the South Bay Sickle Cell Program. The photograph on the right shows Oreese at work at the airport. Below, Joyce is pictured at her desk when she worked for the US Navy before her job as a teacher in San Jose. (Both, courtesy of Joyce Elmore.)

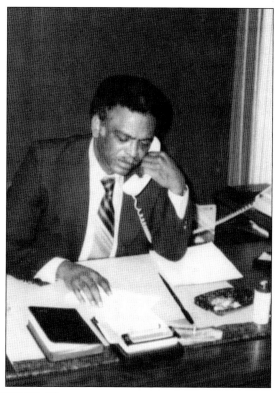

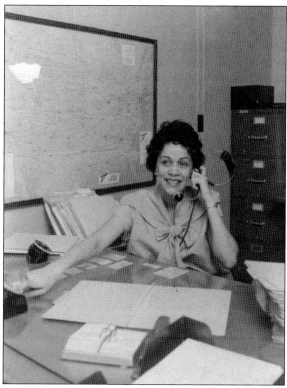

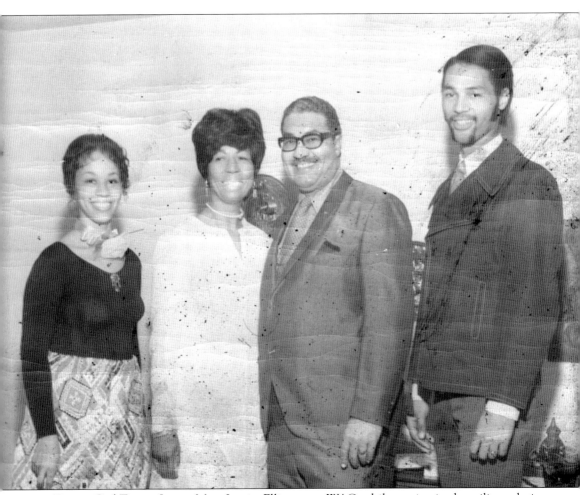

Francis Carl Tanner Jr. met Mary Louise Ellington, a WAC, while serving in the military during World War II, and they married in 1946 in Indiana. They relocated to San Jose in 1947 and raised their two children, Francis Carl Tanner III, right, and Lynda Carole Tanner, left, in San Jose. Mary was employed by Santa Clara County as a social work supervisor for over 15 years. After retiring, she became an accomplished photographer and wrote a book, *Even the Mind Obey*, in 1972. She was also a renowned painter. Mary was the daughter of Napoleon and Bertha Ellington and the sister to Robert and Gloria Ellington Anderson. She graduated from San Jose High School. In 1950, Francis Tanner Jr. became the first African American police officer with the San Jose Police Department. He died in 1991 at the age of 69. (Courtesy of Linda Tanner Horn.)

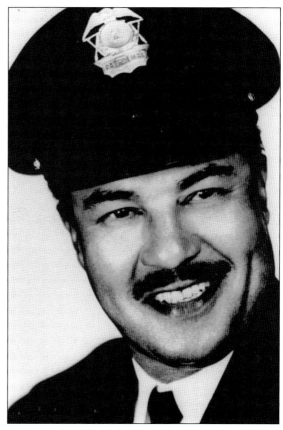

In 1950, Francis Carl Tanner Jr. became the first black police officer in San Jose. According to Phillip Ellington's family, Phillip Ellington, the first black volunteer reserve officer, encouraged Francis to pursue a career as a San Jose police officer since Francis had served in the military as an army medic. Tanner worked for the police department for 21 years. In a *Mercury News* article on February 15, 1987, Tanner said, "I dealt with some people who didn't like having to deal with a cop with my color of skin, but I am proud to say that I never pulled my weapon on anyone or carried a club." He expressed that people in San Jose have always been able to respect someone as a person. Below, Frank Tanner is escorting citizens across the street in San Jose. (Both, courtesy of Sgt. John Carr Jr.)

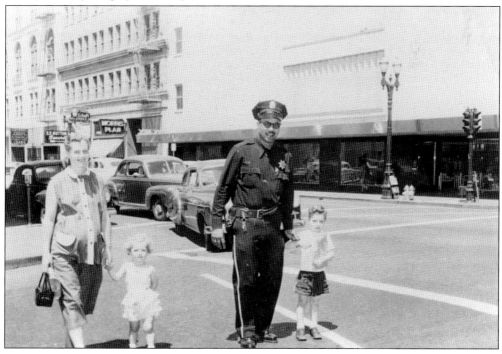

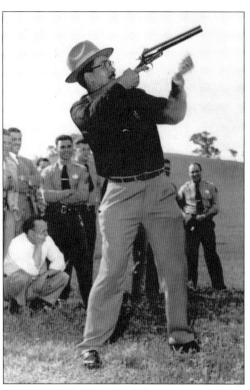

Francis Tanner, left, served as a patrolman for 21 years. Here, he is pictured at range training. (Courtesy of Sgt. John Carr Jr.)

In the 1970s, Francis Tanner served on the grand jury for Santa Clara County. His family believes he was the first African American to serve on the grand jury. (Courtesy of Sgt. John Carr Jr.)

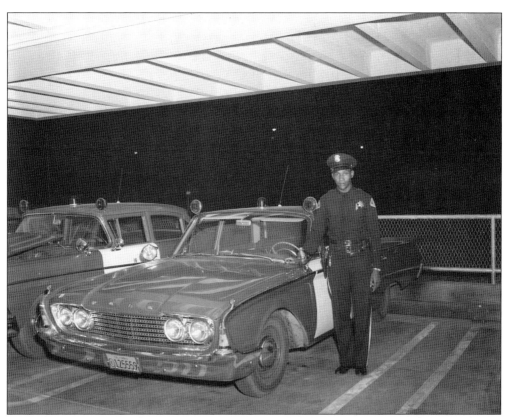

Lee Brown was first introduced to law
enforcement in San Jose in 1960. He served
with the San Jose Police Department during the
same time as Francis Tanner. Brown served for
eight years, from 1960 to 1968. He became the
first black officer to be promoted from patrol to
sergeant. Sergeant Brown established the Police-
Community Relations Unit and reported directly
to the chief of police. While employed with the
police department, Lee completed two master's
degrees: one at San Jose State in sociology and
the other at UC Berkeley in criminology. Brown
received his PhD in criminology from UC
Berkeley and went on to serve in key positions
with police departments throughout the county.
From a sheriff's department in Oregon to
police commissioner in New York and mayor in
Houston, Texas, Dr. Brown continues to work
in the field of criminology throughout America.
During President Clinton's administration, Dr.
Brown served as the "drug czar." The photograph
above shows Brown as a patrolman working in
police community relations; at right, Dr. Brown
is pictured as the drug czar in the Clinton
administration. (Both, courtesy of Lee Brown.)

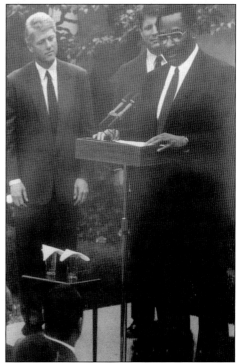

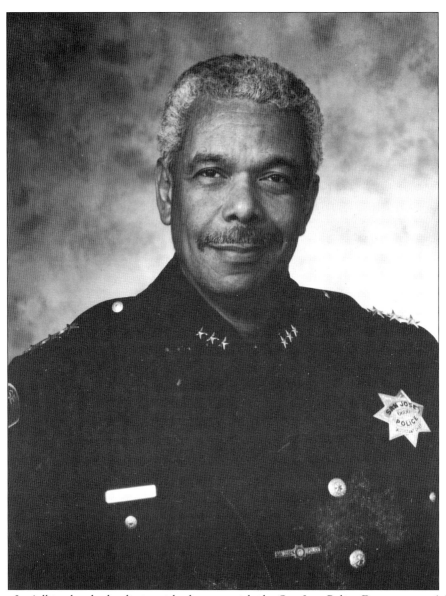

Walter L. Adkins has had a distinguished career with the San Jose Police Department. Adkins began his 29-year career in 1969, rising from police officer through the ranks to acting chief of police, retiring in 1998. He was the first black police officer to achieve the ranks of lieutenant, captain, deputy chief, assistant chief, and acting chief of police. As a non-ranking officer, he was the Hostage Negotiation Team leader and the primary negotiator on several barricade, suicide, and hostage events. Other assignments included police community relations officer, recruiting officer, juvenile gang investigator, and internal affairs investigator. As deputy chief with the Bureau of Administration, he was responsible for hiring 50–80 new officers annually, of which many were of various cultural groups and women. Adkins organized and became the first president of Officers for a Better San Jose, a group of black officers who addressed discriminatory practices within the police organization as well as issues adversely affecting the community. He attended San Jose State University for his bachelor of science degree in behavioral science and master of arts degree in public administration. (Courtesy of Walt Adkins.)

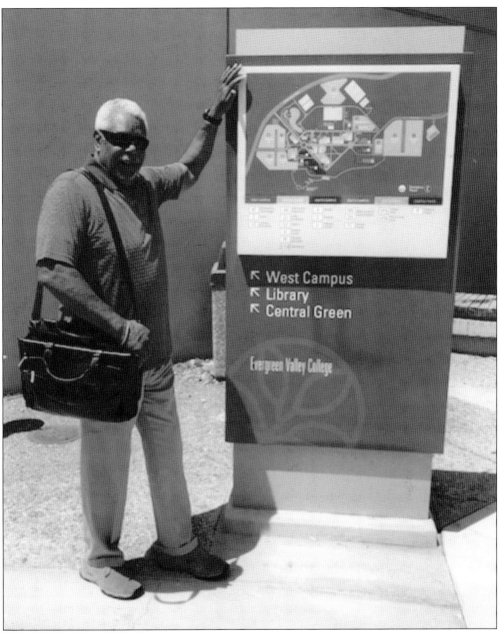

Walter Adkins is a charter member of 100 Black Men of Silicon Valley, a lifetime member of the NAACP, and was a member of the National Organization of Black Law Enforcement Executives. Since his retirement in 1998, Adkins has taught American government and politics as well as various administration of justice courses at the College of San Mateo, De Anza College, Evergreen College's Affirm Program, and at his alma mater, San Jose City College. On behalf of his students, Professor Adkins has written letters of recommendations, attended court, tutored, and on one occasion provided emergency shelter. Prior to retiring in 1998, Adkins taught in the Police Academy at Evergreen Valley College for many years. His advice to students starting the journey of life today is: "You are the master of your destiny; you are the captain of your ship." (Courtesy of Walt Adkins.)

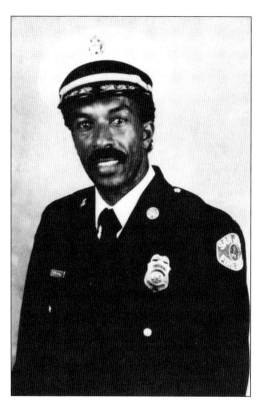

Robert Edward Osby served as chief of the San Jose Fire Department from 1985 to 1992. He was the first African American hired as chief. Since then, two other African Americans with experience in fire safety have been selected to lead the department, Ray Brooks and Curtis Jacobson. Chief Osby started his career in fire safety in 1958 in San Diego. He had been serving as chief for the Inglewood Fire Department for five years prior to his appointment as San Jose's chief in 1985. As chief in San Jose, he increased the number of women and minority recruits and promotions within the department. He also recruited the first black woman firefighter, Teresa Deloach Reed, who later became the chief of Oakland's fire department. (Courtesy of Russ Hayden.)

In 1986, Teresa DeLoach Reed became San Jose's first African American female firefighter. Reed was hired by Chief Robert Osby. Throughout her 26 years with San Jose, Reed was promoted to every position in the department. She served as interim chief in 2010 and retired as assistant chief in 2012. One of her favorite jobs was administrator of training and operations. Throughout her career, when possible, she mentored women and minority trainees in the academy. She was often invited to speak to youth, especially girls, about careers in firefighting. After her career in San Jose, in 2012, Chief Reed was hired as the first female fire chief for the Oakland Fire Department, becoming the first black woman fire chief in the country. (Courtesy of Teresa Deloach Reed)

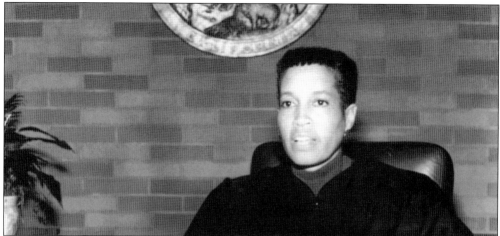

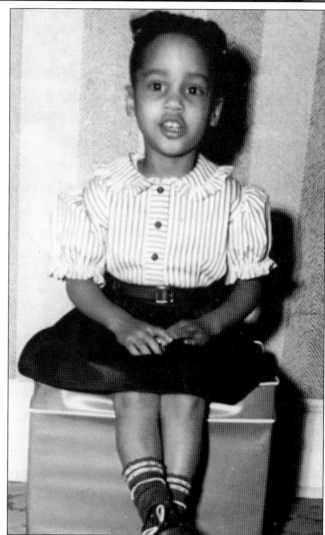

Judge LaDoris H. Cordell, retired Superior Court judge, was the first African American to serve on the Superior Court in Santa Clara County. After graduating from Stanford Law School in 1974, Cordell opened a law office in East Palo Alto, where she practiced law from 1975 to 1982. From 1982 to 2000, Judge Cordell served on the bench in several courts. She was a judge in Municipal Court, Family Court, and Superior Court. She also served in 1993 as the presiding judge of the Superior Appellate Department. Judge Cordell's contributions extend beyond the courtroom. She served on the Palo Alto City Council from 2004 to 2008, and in 2010, she became the independent police auditor for the City of San Jose. At right is LaDoris Cordell at four years old. Already, she is sitting on a bench. She is the daughter of activists Lewis and Clara Hazzard, who taught her: "Remember you did not get there by yourself. Your ancestors suffered greatly to survive. We must give back." (Both, courtesy of LaDoris Cordell.)

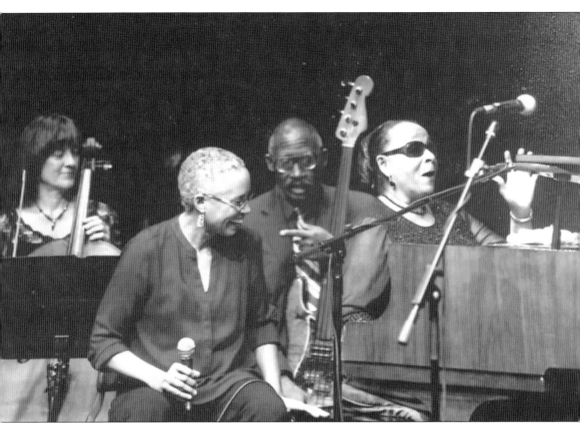

After retiring from the bench, from 2001 to 2009, Judge LaDoris Cordell served as Stanford University's vice provost and special counselor to the president for campus relations, supervising the Office for Campus Relations. Cordell is the cofounder of the African American Composer Initiative, which presents the works of living and historical African American composers. The initiative, founded in 2009, began presenting annual concerts by African American composers in 2010. The concerts are located in the Performing Arts Center of Eastside College Preparatory School in East Palo Alto. All proceeds benefit the school. This photograph shows Valerie Gapers, jazz pianist (right), and LaDoris Cordell (with microphone) performing at the 2014 concert. They are singing a duet, "I'm Beginning to See the Light." (Courtesy of LaDoris Cordell.)

From 1972 to 1990, W. Steve Stevens, born in Arkansas in 1934, was the first African American lawyer employed at the Santa Clara County Public Defenders Office. His job required him to provide legal defense to low-income clients seeking legal services. At the time, Stevens was the first black attorney hired and the sole African American for many years. During his time there, he worked to get other black attorneys hired. Stevens graduated from Stanford Law School in 1972 and started the South Bay Black Lawyers Association. He served in the Air Force from 1969 to 1971. The photograph at right shows Steve Stevens at the Santa Clara County Public Defenders Office. Below, he is with daughters Stephanie and Starla. Stephanie became a member of the California Bar Association in 2005. Stevens retired from the public defenders office in 1990. He is a 33rd degree Mason. (Both, courtesy of Sheila Stevens.)

Deputy district attorney Ulysses Beasley, originally from Arkansas, was the first African American prosecutor with the Santa Clara County District Attorney's Office and served for over 23 years. Beasley, who retired in 1989, had a reputation of being a tenacious fighter for the cause of justice. He was very compassionate with trouble children. As a graduate of Fresno State University, Beasley completed his law degree from San Francisco University Law School, graduating in 1965 and moving to San Jose in 1966. Before coming to San Jose, he worked as a Fresno police officer, a social worker, and an alcohol and beverage control investigator. He was able to use all of these experiences in his job as a prosecutor. He married Rose, of Fresno, in 1960, and they raised three children in South San Jose. (Courtesy of Beasley family.)

Here is the Beasley family in 1989. From left to right are son Mark, a probation officer with Santa Clara County; daughter Erica; Rose; and Ulysses. According to the family, Ulysses Beasley was dedicated to getting at the truth. He would often say, "There is their truth, my truth, and God's truth, my job is to get close to God's truth." He would also say, "I didn't want anyone to say I was a token hired because I was black. I heard that all of my life. I said to myself, the only way to do things is like Joe Louis, knock 'em out and leave no doubt." (Courtesy of Beasley family.)

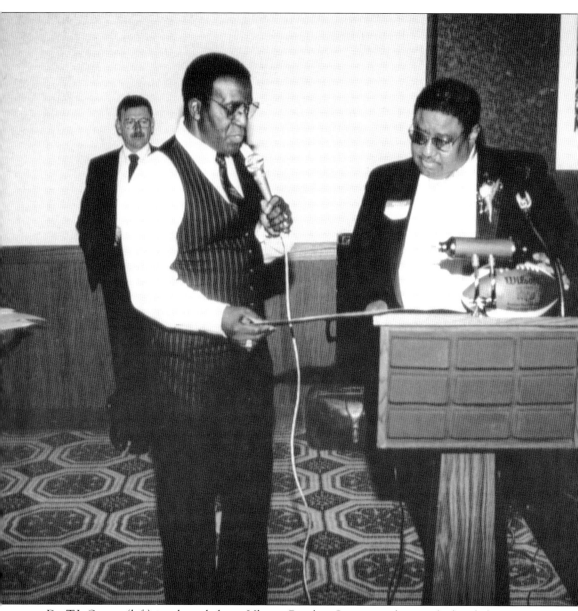

Dr. T.J. Owens (left) is acknowledging Ulysses Beasley. Owens was known for his dedication to the institutions of education throughout Santa Clara Valley. He worked more than 40 years in education throughout the county. After moving to Silicon Valley from Barstow and Fresno in 1968, Owens served as the president of San Jose's NAACP in 1969 and advisor to the Black Student Union at San Jose City College. He was a founding member of the state funded Educational Opportunity Program for minority students. In 1973, Owens was promoted to dean of students at San Jose City College, and in 1991, he moved on to Gavilan College, where he served as vice president of student services. He retired in June 2000. Dr. Owens was involved in many community organizations, such as the 100 Black Men of Silicon Valley, the Gilroy Gang Task Force, and the Santa Clara County Grand Jury. He believed that the pursuit of personal excellence would produce responsible citizens and capable leaders who could ultimately serve the community. (Courtesy of Beasley family.)

Dr. Leo V. English Jr., a graduate of Howard University, and his wife, Juanita English, moved to San Jose in 1954 so Dr. English could establish his practice in general medicine and surgery. After moving to San Jose, Leo and Juanita English attempted to buy a home and rent office space but were denied based on their race. They ended up finding a home near San Jose Hospital and converted the front into a medical office and used the back of the home for the family. Dr. English had a strong sense of community responsibility and served as president of the San Jose branch of the NAACP from 1960 to 1961. He received the Good Neighbor Award in 2002 from the MLK Association, served as a member of the San Jose police chief's advisory board, and was a member of the Santa Clara County Grand Jury and the Santa Clara University Board of Regents. He also cofounded an HMO. Dr. English served on the staff of several hospitals throughout Santa Clara County. (Both, courtesy of English family.)

Juanita English, a community activist and wife of Dr. Leo English, has served the San Jose community through her volunteer work since 1954. Based on their experience with discrimination, they joined the NAACP in the 1950s to address housing discrimination problems in San Jose and to help others find housing. Juanita's volunteerism has continued over the years; she has served as youth director of the NAACP of San Jose and is one of the founding mothers of the San Jose chapter of Jack and Jill. In 1975, she returned to school and received her master's degree in counseling psychology from Santa Clara University. She became a licensed marriage and family counselor and worked at Alum Rock Counseling Center. She has served on the county mental health committee, addressing infant mortality among African Americans. Juanita has received many awards for her extraordinary achievement and for being an inspiration to women. Leo and Juanita raised four sons who attended schools in San Jose. (Courtesy of English family.)

Iola Williams moved to San Jose in 1970 and became the first African American elected to the San Jose City Council, a post she held for 12 years, including two terms as vice mayor. Williams also served as vice chair of Silicon Valley's 22-mile light-rail project. Her lobbying efforts helped to secure over $280 million in federal transit dollars for the project. She was very concerned with services for seniors, particularly health programs. The Senior Center in District 7 was named the Iola Williams Senior Center. Her philosophy on life is, "I don't brag. I get things done." She often stated, "God is in control, and not us." (Courtesy of African American Community Service Center.)

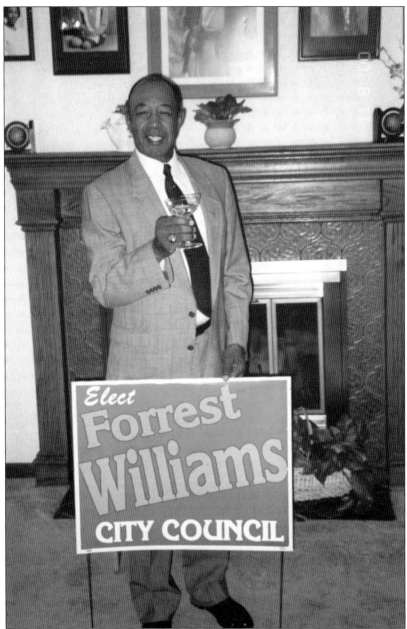

Dr. Forrest W. Williams moved to San Jose in 1968 and became the second African American elected to the San Jose City Council, serving from 2001 to 2008. Williams, an electrical engineer, came to San Jose to work in the field of technology. He has worked in engineering at the Boeing Company, GE, and IBM Corporation on a variety of projects. Williams received his PhD from San Clara University in 1988 in engineering. Since 1986, Dr. Williams has served the community as a trustee for the Oak Grove School District. He was a member of the San Jose Planning Commission from 1991 to 1999, and a board member of the Santa Clara Valley Science and Engineer Fair Association. He currently serves as a trustee for First AME Zion Church. His advice to students is to get a well-rounded education and be capable of competing in the global economy. (Courtesy of Forrest Williams.)

Roy L. Clay Sr. was the first African American to serve on the Palo Alto City Council. Clay also served as vice mayor in 1973. In 2003, Clay, a mathematician and "giant" in technology, was inducted into the Silicon Valley Engineering Hall of Fame. From Missouri, he was employed at Lawrence Livermore National Laboratory, Hewlett-Packard Corporation, and then started his own company, Rod-L Electronic, in 1977. Clay is considered by some in technology as the "Black Godfather of Silicon Valley." He invented the electronic equipment safety testing device certified by Underwriters Laboratory. Clay helped to organize networking events for black technology workers. He believed "the way to get through is to get African Americans in positions to do things so we can get others in positions to do things." His advice to students when he received the Black Legend Awards–Silicon Valley 2015: "You will experience racism for the rest of your life, but don't ever let that be a reason why you don't succeed." (Courtesy of Palo Alto Historical Association.)

Benjamin F. Gross Sr. moved to Silicon Valley in 1954. In 1949, he became a member of the United Auto Workers Local 560, and in 1950 was elected to the bargaining committee. He was then named chair of the housing committee. He served on the Milpitas City Council from 1962 to 1971. Gross was elected mayor of Milpitas in 1964 and reelected in 1968. When the new Ford Motor Company plant opened in Milpitas, several hundred African American workers had to find housing in Santa Clara County, where housing discrimination existed. Gross met with San Jose developers and pledged to build affordable housing that would welcome all races. The result was the Sunnyhills development in northern Milpitas. Sunnyhills was the first planned interracial community in America sponsored by a labor union. Gross was inspired to oppose racial discrimination after being restricted from entering the downstairs of a theater and forced instead to sit upstairs. His advice is "Don't let your race stand in the way of your progress." (Courtesy of City of Milpitas.)

Named for former Milpitas mayor Ben Gross (1921–2012), Gross Street is located in the city's Sunnyhills neighborhood. In addition to being the first black mayor of a sizeable city in the United States, Gross's dedication to community service led to his repeated elections to the city council. He initiated the request that eventually led to having a Russian delegation, including Nikita Krushchev, visit Milpitas in 1962 to experience a racially integrated neighborhood. (Courtesy of Jan Adkins.)

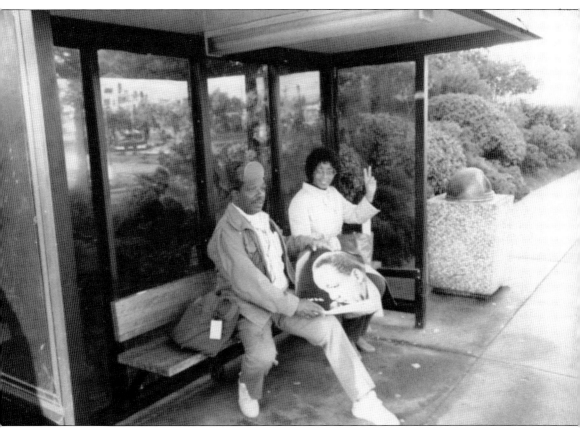

Henry Gage moved to San Jose in 1967 after 23 years of military service. As a resident of San Jose for 46 years, he worked to improve the lives of San Jose's citizens. In the 1970s, he served as president of the NAACP and in 1974 was elected to the Eastside Union High School District Board of Trustees. At one point during his 14-year tenure on the board, he served as president. As a parent of children in public schools, Gage became concerned about the academic success of minority students in local schools. While on the school board, he formed a black and Hispanic coalition that pushed for curriculum changes, particularly in mathematics, and the hiring of black and Hispanic teachers. Gage was also instrumental in the recovery of millions of dollars for local school districts from misdirected funds. He coauthored an autobiography of his life titled *Plantation Life on Old River and Beyond*. This photograph shows Henry Gage and Francine Bellison protesting in Forsyth County, Georgia. (Courtesy of Francine Bellison.)

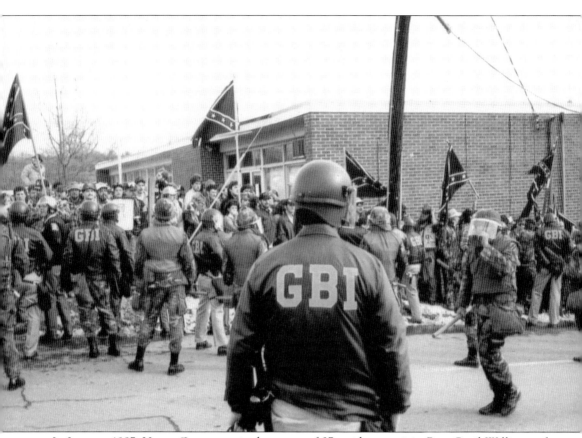

In January 1987, Henry Gage organized a group of 37 residents to join Rev. Cecil Williams of Glide Memorial to attend a civil rights march in Forsyth County, Georgia. The march was held to protest the fact that blacks had been forbidden to live in Forsyth County since the last lynching in 1912. In this photograph, the marchers were greeted by hecklers and gangs of boys mobilizing against them. San Jose community leaders attending were John Hill, chairman of the Santa Clara Valley Urban League; Betty Dunson, a former resident of Atlanta and cofounder of the Martin Luther King Jr. Center for Social Change of the Santa Clara Valley; Francine Wright Bellson, an engineer/physicist at IBM; Chuck Alexander, retired county Boys Ranch manager; and Henry Gage, president of the NAACP's San Jose branch. (Courtesy of Francine Bellison.)

Six

THE BLACK COMMUNITY
CREATING OPPORTUNITIES
AND OPENING DOORS

1970–PRESENT

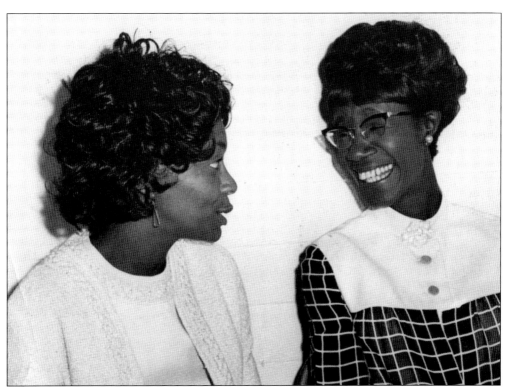

Once African Americans established a sense of community and place for addressing the issues and needs of black citizens, individuals went to work giving a lift to those in need. For many volunteers, the goal has been to address specific issues of education, police community relations, participation in local government institutions, employment opportunities, and celebration of the culture. Many feel the need to reach back and help others achieve also. In this 1969 photograph is Congresswoman Shirley Chisholm advising Beatrice Cossey of the Business and Professional Women's Association of Palo Alto. (Courtesy of Ocie Tinsley; photograph by Jean Libby.)

Inez Jackson and her family moved to San Jose in 1944. She is characterized by some as a "newcomer who politically agitated for equal opportunities." In search of the American Dream, Inez Jackson was an experienced schoolteacher from Oklahoma in search of a place where discrimination did not exist and where she could teach in an integrated setting. When she arrived in San Jose, she was told black teachers were not hired. Abandoning her dreams, in 1949 she found work at the US Postal Service, where she retired 24 years later. Jackson and others faced a subtler racism in Santa Clara County. She worked to establish organizations and opportunities to improve the lives of black citizens in San Jose. She helped to establish the African American Community Service Agency and the Inez C. Jackson Black Historical Research Library (below), dedicated in 1981. She served on many boards and joined organizations in her fight for equality. Jackson received numerous recognitions and awards, ranging from the mayor's commendations to a letter of recognition from Pres. George Bush. (Both, courtesy of AACSA.)

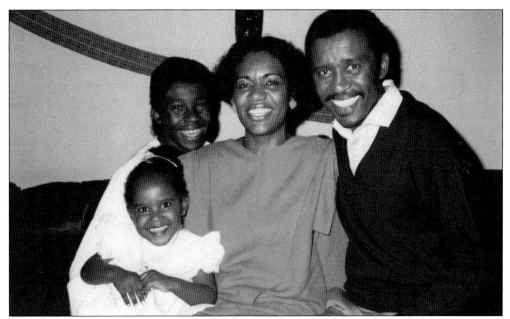

Carl and Brenda Ray's contribution to youth in the valley has extended over 40 years. Carl mentored youth and organized Historically Black Colleges and Universities (HBCU) tours for more than 5,000 students over 30 years. He helped students realize the possibility of achieving a college education. Carl, an electrical engineer, graduated from Tuskegee Institute in 1967 and moved to the Bay Area to work at Lockheed. He married Brenda, a San Jose State University graduate, in 1973. In 1978, Carl decided to pursue his dream of becoming a stand-up comic. By 1989, he was host and producer of his own cable comedy show. Brenda, a speech pathologist and educator, worked with Santa Clara Valley youth in two school districts as a classroom teacher, resource teacher, and administrator. Today, after retirement, Brenda continues the legacy of giving back to the community by her involvement in research and special projects. In the 1988 photograph above are Carl and Brenda Ray and their two children, Ania and Ejalu. Below, Carl (center) is receiving a leadership award. At left is Congressman Mike Honda, and in the back left is Mayor Ron Gonzalez. (Both, courtesy of Brenda Ray.)

Carl Ray (pictured) was an author, performer, and motivational speaker. He wrote and performed a one-man play, *A Killing in Choctaw*, throughout America and Grenada, which eventually became a documentary in 2004. He also authored *Cured: The Power of Forgiveness*, which is the story of his life. Ray received many awards for his contributions to the youth of Santa Clara Valley. He passed away in 2014. (Courtesy of Brenda Ray.)

This photograph shows Carl Ray, in the middle with a coat on, talking to his students on an HBCU tour. For 30 years, Ray organized these tours during the fall and spring for high school students. His focus was on academic improvement for African American students. He was best known for his love for the black community. Ray believed "freedom is on the other side of forgiveness." (Courtesy of Brenda Ray.)

Dr. Joyce King, an internationally renowned educator, was educated at Stanford University, and after completing her PhD in sociology and education in 1974, became the director of teacher education at Santa Clara University. Now, through research and teaching at Georgia State University, she is providing answers to the crisis of an educational system that is failing African/African-ancestry children. She suggests it is the responsibility of the community to transform education and restore academic and cultural excellence for black children and youth. (Courtesy of Joyce King.)

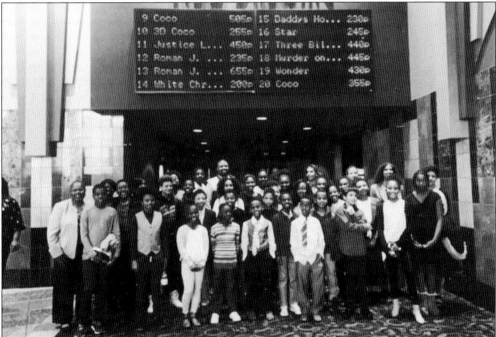

Debra I. Watkins, an educator for over 30 years, has made it her personal mission to address the opportunity gap of black students throughout Santa Clara Valley by developing programs aimed at improving the lives of children and youth. Since 1998, she has been the founder and executive director of the Dr. George Washington Carver Scholars program, the Frank S. Greene Scholars Program, California Alliance of African American Educators, and A Black Education Network. Watkins is pictured here (first row, far left) with Frank S. Greene Scholars on a field trip. (Courtesy of Debra Watkins.)

Dr. Byran Clift Breland, acting chancellor for the San Jose Evergreen Community College District and former president of San Jose City College, believes community college must create opportunities for people to participate in the local economy through education and specialized skill development training. He sees community colleges as a resource for employment enrichment and support services for student success. Dr. Breland believes every individual has the aptitude to be great with the necessary support. (Courtesy of B. Breland.)

Keith Aytch, president of Evergreen Valley College, has served students in various positions at Evergreen Valley College for over 24 years. From instructional faculty to division dean to vice president of instruction to president, Aytch believes the community college must address issues of opportunity, equity, and social justice to ensure the success of African American students as well as all students. (Courtesy of K. Aytch.)

Leon Beauchman, originally from Los Angeles, attended San Jose State University in 1968 to compete in track and field, football, and basketball. For many years, he has served as president of the Santa Clara County Alliance of Black Educators (SCCABE). For the last 29 years, SCCABE has held its annual Student Recognition Program each spring to acknowledge the positive student achievement and efforts of students in a variety of categories. Under Beauchman's leadership, SCCABE sponsors several programs throughout the school year, such as back-to-school events with notable speakers for middle school and high school students and a San Jose Multicultural Artist Guild/Tabia African American Theatre Ensemble event to provide middle and high school students with opportunities to see and discuss selected plays performed by talented actors during Black History Month. Beauchman and his wife, Nejleh, raised three sons in San Jose who attended local schools. (Courtesy of Leon Beauchman.)

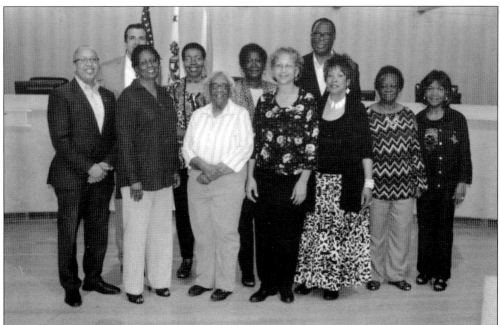

SCCABE board members receive a commendation from the San Jose City Council in 2015. From left to right are (first row) Councilman Charles Jones, Antoinette Battiste, Dorthey Myers, Cyd Mathias, Carolyn Walker, Annie Handy, and Brenda Smith; (second row) Mayor Sam Liccardo, Carolyn Johnson, Josephine Miles, and Leon Beauchman. (Courtesy of Leon Beauchman.)

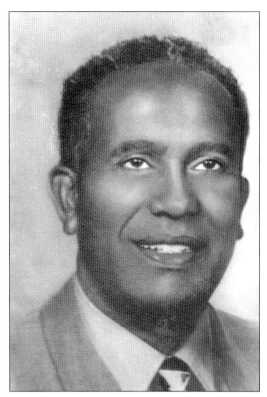

Frank Sypert was dedicated to improving relationships between people by promoting racial understanding. In 1959, Sypert moved his family to San Jose from Oklahoma and for 15 years supervised the evening shift at the city garage. He maintained the San Jose Police Department's fleet of vehicles and managed its rotation. In honor of his dedication to the city and his work toward building police and community relationships, in 1979 the San Jose City Council named the former city fire station on Julian Street the Frank Sypert Afro-American Community Service Agency. Below, Sypert is pictured in the 1940s with his wife, Ruby, and their daughter Tedie. Sypert was a Tuskegee Airman during World War II. (Both, courtesy of Tedie Wells.)

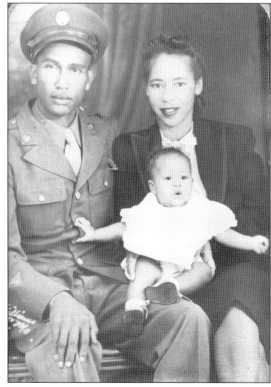

Tedie Wells, an engineer at Bell Systems in San Jose, began her career in 1961 and by 1976 was promoted to district manager in charge of cable engineering for Contra Costa County. Before Wells retired in 1987, she recruited African Americans, other minorities, and women for jobs traditionally not available to them. She mentored and counseled women and minorities on how to succeed at Bell Systems, as she had done. Wells says she would rather work within the system to open doors for minorities and females. She is pictured here (far right) celebrating Christmas with her grandchildren. (Courtesy of Tedie Wells.)

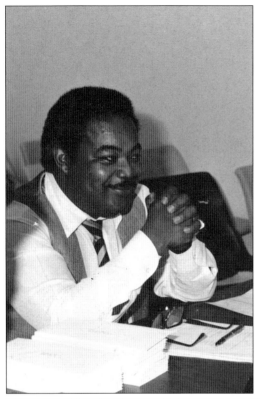

Tommy J. Fulcher Jr., a Harvard MBA graduate, served as the president/CEO of Santa Clara County's Economic and Social Opportunities Inc. (ESO) from 1982 to 2007. ESO was a nonprofit organization established to provide low-income households with employment services, housing-related service, childcare, women's health care, immigration employment opportunities, and other social services to residents of Santa Clara County. Fulcher was responsible for networking with the private sector to bring resources to ESO. Below, he is pictured in his role as advisor in establishing the Urban League in San Jose. He served as the NAACP president in the 1980s and helped to raise money for community events. He also served on the police promotion board and worked toward improving the relationship between police and the community. Fulcher feels his most significant contribution to the people of Santa Clara County was to encourage poor people to pursue what they needed for their families. Fulcher and his wife, Gale, raised three sons who attended local schools. (Both, courtesy of Fulcher family.)

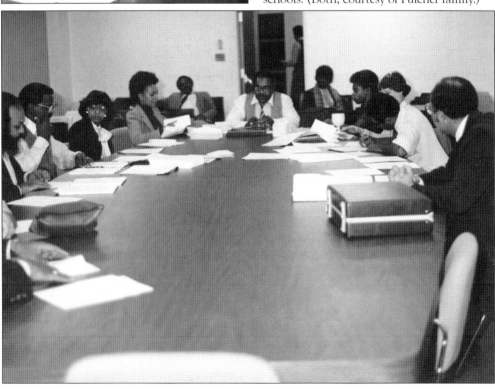

Dr. Frank Greene, a technology pioneer, moved to Silicon Valley in 1960 and worked at Fairchild Semiconductor R&D Labs. He was the first black technologist to break through race barriers. He started two technology companies and later founded NewVista Capital, a venture firm that focused on minority- and female-led firms. Greene launched the GO-Positive Foundation, which offered leadership programs for high school and college students. He was inducted into the Silicon Valley Engineering Hall of Fame and serves as the inspiration for the Greene Scholar Program, which assists students in successfully completing higher education in STEM. Dr. Green is known for venture capital funding and holds patents for the integrated circuit that made Fairchild a semiconductor leader in the late 1960s. He received the Black Legend Award in 2015. His advice to students was, "Always play fair and leave the world a better place than you found it." Dr. Frank Greene passed away in 2009. (Courtesy of Greene family.)

Frank Green (center) is pictured here receiving an award. Standing next to him is San Jose city councilwoman Iola Williams (right). (Courtesy of Greene family.)

Wilbur Jackson moved to Silicon Valley in June 1976 to work at IBM in management. Beginning in 1977, he volunteered in the community with youth ranging from middle school to high school. He is the national coordinator for Project Alpha and volunteers with the Boy Scouts, Police Athletic League, Rites of Passage, Boys Teen Pregnancy Prevention, and several other organizations. Jackson has served on the Black Kitchen Cabinet as the secretary. When working with youth, he helps students navigate through racism and not let it cause them to be victims. Jackson believes it is important to give students the tools to fight racism effectively. He is pictured below with his fraternity brothers at a Project Alpha fundraiser. (Both, courtesy of Wilbur Jackson.)

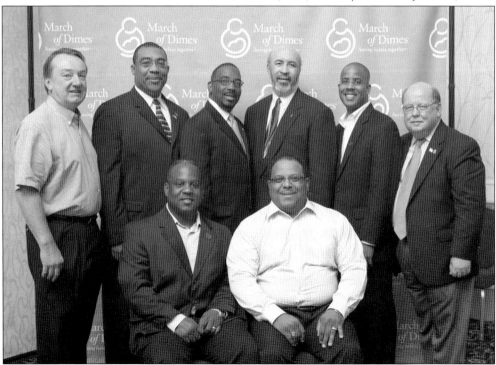

Rufus White (left) was hired by IBM and moved to San Jose in the summer of 1969. IBM's directive was to hire talented black employees. After 34 years of working in technology, White retired and volunteers with organizations dedicated to mentoring and developing youth, specifically through high school technology programs and the Rites of Passage program. (Courtesy of Rufus White.)

Elroy Smith (right), a graduate of Yale and Stanford Universities, was one of the first African Americans who worked as an engineer at IBM. Between 1962 and 1995, Smith was involved with various aspects of the company such as forecasting, programing, and planning of computers. Between 1965 and 1975, Smith recruited talented black graduate students from black colleges as well as other colleges throughout America for IBM. he was also the founder of the Paul Robinson Society. (Courtesy of Sue Smith and family.)

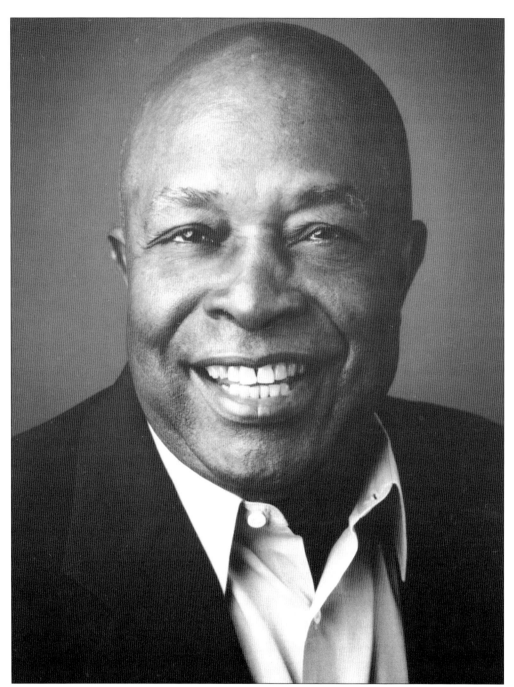

Ken Coleman, chairman of Saama Technologies and the founder, chairman, and CEO of ITM Software Company, has worked in the Santa Clara Valley since 1972. In 1973, Coleman established Black Student Day at Hewlett Packard (HP). This was an opportunity to expose black high school students to technology. When Coleman left HP in 1982, this tradition continued at HP. Coleman states he would like to see more African Americans and women in every role throughout technology companies, from engineers and CEOs to boards of directors and general counsel. (Courtesy of Ken Coleman.)

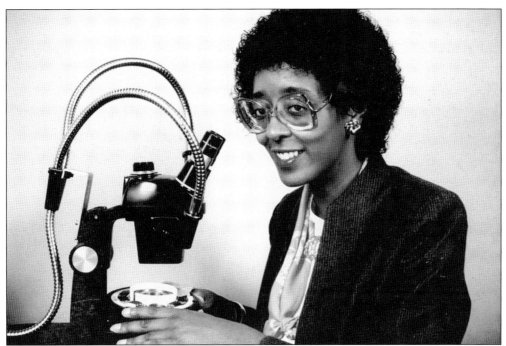

Francine Wright Bellson, a physicist from MIT, moved to San Jose in 1974 and joined Fairchild Semiconductor. From 1978 to 1992, she worked as an engineer and scientist at IBM. While there, she joined Black Engineers in Northern California and began mentoring and encouraging African American youth, and girls in particular, to consider technology careers. Bellison continues meeting with youth groups throughout the Bay Area to discuss math, engineering, and science achievement, and to teach the "Wright Stuff:" motivation, awareness, vision, and courage. She is pictured at right in 1992 with renowned musician and husband, Louis Bellson. (Both, courtesy of Francine Bellson.)

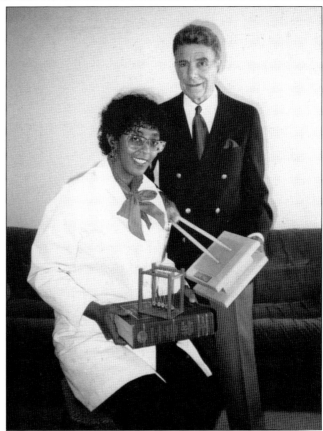

One of Francine Bellson's former classmates was Ron McNair, who perished in the *Challenger* space shuttle explosion in 1986. She shares with students the story of how Milpitas High School students gave McNair a MESA lapel pin (pictured) to carry into space in his bag. McNair's bag was recovered, and the pin was returned to the students of Milpitas High School. It is now displayed in a plaque at San Jose State University. (Courtesy of Francine Bellson.)

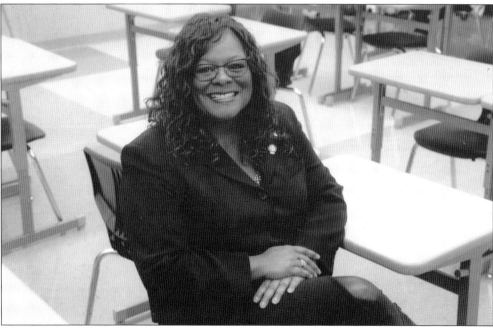

After 33 years in the corporate world, Sandra McNeal of Morgan Hill has been an inspiration to teens from Morgan Hill High School. Since her retirement from Abbot Laboratories, McNeal has used her position with the chamber of commerce to create a program that provides students with interviewing skills, as well as training on how to dress and prepare for a job interview. In 2018, she was named Volunteer of the Year by the Morgan Hill Chamber of Commerce. (Courtesy of Sandra McNeal.)

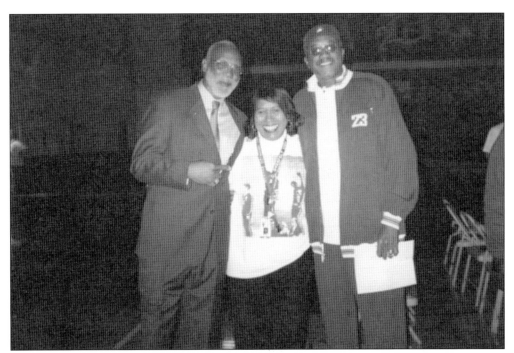

Hellen Simms has lived in San Jose since 1962. In 1968, she was the first African American woman hired by the Santa Clara County Sheriff's Department as a community relations representative. In 1970, Simms began teaching high school social studies. She retired in 2009. Simms has served the San Jose community since 1970, through projects like Jack and Jill, NAACP, Links Inc., and the AKA sorority. She is pictured with Tommy Smith and John Carlos. (Courtesy of Hellen Simms.)

Dr. Harriett Arnold, author of *Antioch: A Place of Christians, Chronicles of an African-American Church, 1893–1993*, is a member of Antioch Baptist Church. She serves the San Jose community by maintaining the history of one of San Jose's oldest Baptist churches. Since 1999, Dr. Arnold has been an associate professor at University of the Pacific and serves as president of the San Jose State University Alumni Association. She has been an educator in Santa Clara County since 1972. (Courtesy of Harriett Arnold.)

Dr. Gerri Forte has had a distinguished career as an educator since 1973. Between 1990 and 2010, she was an administrator at schools in Merced, Ravenswood, Tracy, Milpitas, and Fremont Unified School Districts, and at East Side Union High School and Oak Grove High School. Now in retirement, she is an adjunct professor at Santa Clara University. Dr. Forte enjoys working with ESL students while preparing for their doctoral work. She volunteers many hours mentoring girls in grades four through eight in science, technology, engineering, arts, and mathematics in STEAM–oriented careers through the National Coalition of 100 Black Women, Silicon Valley Chapter, and the Light House of Hope Counseling Center. (Courtesy of Gerri Forte.)

Rev. Steven Pinkston has followed his father's path as an educator and minister of the gospel. Pinkston has been teaching at Bellarmine College Preparatory School for 38 years in areas of math, religious studies, and social studies (African American experience). He has mentored many students throughout San Jose. As a mentor, basketball coach, dean of students, and director of the Christian Service Program (since 2000), Reverend Pinkston is a widely respected educator and is currently associate pastor at Maranatha Christian Center. (Courtesy of Steve Pinkston.)

Robert J. Stroughter Sr. is a community activist who moved to the Bay Area from Arkansas in 1946. In 1965, he relocated to Silicon Valley. For more than 50 years, Stroughter has served on many advisory boards of nonprofit organizations aimed at addressing the poor and disenfranchised. He was appointed by Mayor Ron James to serve as chairman of the San Jose Urban Coalition Transportation Task Force, and has served on the board of the Youth Services Bureau. (Courtesy of Aaron Hicks.)

Milan R. Balinton, executive director of the African American Community Service Agency (AACSA), has helped to develop and mentor youth in their academic and career pursuits. Through the AACSA, Balinton has provided community-wide programs, services, and activities that strengthen African American identity, culture, values, and traditions. He has received numerous awards and recognitions. (Courtesy of Milan R. Balinton.)

Queen Ann Cannon has lived in San Jose since 1955. She has been a member of many organizations and has served on many boards. Cannon is credited with starting the MLK Luncheon in the 1980s. In 2009, she turned the luncheon responsibilities over to the AACSA, where she continues to chair numerous community-wide events such as a committee for the annual Juneteenth festival. (Courtesy of Queen Ann Cannon.)

The Black Theater Workshop at San Jose State University brought Viera Whye to San Jose in 1979. Whye, cofounder of Tabia African-American Theatre Ensemble and the San Jose Multicultural Artist Guild, works with youth to celebrate African and African American history and family relationships in productions. Whye says she is passionate about theater, "our place in the world, and our story through our lenses." As an art educator, she works with women's shelters and youth in juvenile hall. The photograph below shows the cast of *Steal Away*. (Both, courtesy of Viera Whye.)

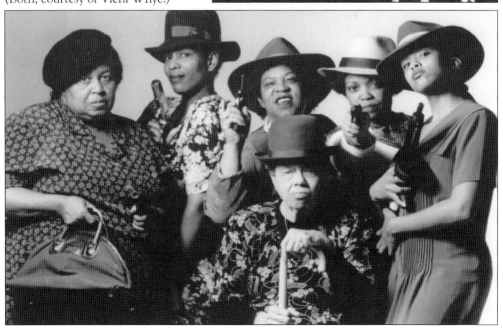

Mary Lizzie and Edward Parrish moved to San Jose from Louisiana in 1955. Edward worked for Ford Motor Company in Richmond and Milpitas for 32 years. He passed away in 1991. As a member of Antioch Baptist Church since 1955, Mary Parrish is currently a "Mother of Antioch." She says she recalls when black people could only work in labor, service, and agricultural jobs. She says that today's San Jose has changed, and there are opportunities for all. (Courtesy of Mary Parrish.)

Doris and Cole Richmond moved to Palo Alto in 1949. In 1958, Doris was the first African American hired by the Palo Alto library system; she retired in 1991 after 33 years, and the Palo Alto City Council honored her for her service. Doris, a charter member of University AME Zion Church, served church members in Christian education, choir, and outreach to new members. Born in 1921, she died on June 6, 2017. (Courtesy of Jean Libby.)

The Garden City Women's Club (GCWC), started in 1906 in San Jose by Northside neighborhood resident Elizabeth Boyer, is an affiliate of the National Association of Colored Women's Club, which was established in 1896. GCWC is a service organization that inspires women of all ages and organizes efforts to serve the community in areas of housing, health, employment, professional careers, civil rights, education, illiteracy, delinquency, and discrimination of all kinds. As a service organization, the GCWC provides gifts to residents in nursing homes, has sponsored the Inez Jackson Girls Club, and since 1955 has awarded over 120 scholarships to high school seniors. In 1978, GCWC received a grant from Lockheed to fund the book *History of Black Americans in Santa Clara Valley*. This photograph shows the leadership of GCWC today. From left to right are (first row) Addie McShepeard, Marianne Smith, Merver Fitch, Inez Jackson, Heneriette Hillams, ? Green, Cleo Hickman, Grace Echols, and Roberta Joyner; (second row) Dareen Keane, Carolyn Ellzey, Aminah Jaki, Frances Jones, two unidentified, Mattelon Smith, unidentified, and Carolyn Walker. (Courtesy of Carolyn Ellzey.)

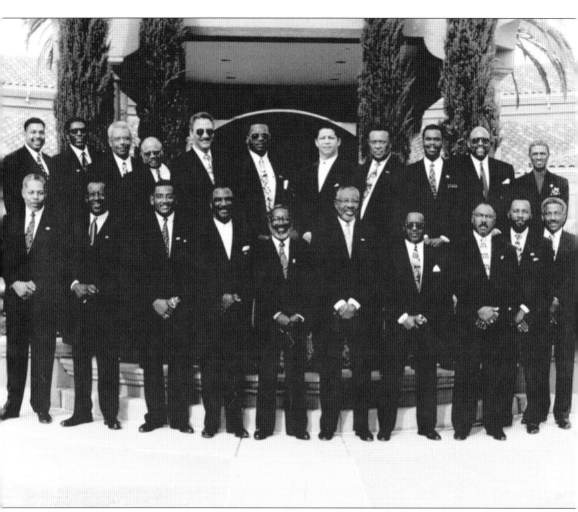

The service organization 100 Black Men of Silicon Valley seeks to reach underserved and underrepresented youth. The national motto is "What They See is What They'll Be." Services of this organization are aimed at disadvantaged low-income youth and families. In San Jose, this group gives college scholarships and mentors and tutors young men in local middle and high schools. This photograph of charter members was taken in 1996 at Silver Creek Country Club in San Jose at the inauguration ceremony for the 100 Black Women of Silicon Valley. From left to right are (first row) unidentified, Felton Owens, Aaron Hicks, Bobby Lee, Sam Brown, Herman Miller, Milt Winfrey, Fred Mitchem, Bill Corley, and Bill Nelson; (second row) Warren Vincent, Shelton Merritt, Walt Adkins, Danny Mack, Joe Bass, Archie Moore, Dr. Casnave, Elbert Reed, Bruce Toney, Bill Kendricks, and ? Ashford. (Courtesy of Walt Adkins.)

Hewitt Joyner has lived in San Jose since 1971 and has served the community's youth, adult education, and youth employment programs. He is currently president of the Silicon Valley Black Chamber of Commerce. He, along with Aaron Hicks, established the Black Legend Award–Silicon Valley, where black leaders are recognized annually for their service to the community. (Courtesy of Hewitt Joyner.)

Aaron K. Hicks Jr., committee chair/project manager of Black Legend Award–Silicon Valley, coordinates the annual award ceremony held in San Jose. He is committed to recognizing the contributions of the many African Americans throughout the Santa Clara Valley who have helped build the community. Hicks has provided ongoing community service to the Joyner/Payne Youth Services Agency as a board member/vice chairman. (Courtesy of Aaron Hicks.)

Janice L. Edwards, journalist and television host for many years, has highlighted local people and issues throughout Santa Clara County that need community support and resources. As a journalist, she tries to bring visibility to Silicon Valley. Edwards has served as the community relations director and executive producer and host of *Bay Area Vista* at NBC Bay Area. She has received many awards for her show and was voted best host of a non-news program. The photograph above shows Edwards with Jessie Jackson, who was a guest on *Signature Silicon Valley*. Below, Edwards is pictured with Afrikahn Jahmal Dayvs, founder of the JaZzLine Institute, serving as hosts for the Black Legend Award–Silicon Valley. (Both, courtesy of Janice Edwards.)

Loretta Green moved to Palo Alto with her husband in 1971. She is an award-winning journalist who has devoted her professional life to writing for local newspapers such as the *Palo Alto Times* as a reporter and feature writer and as a columnist for the *San Jose Mercury News*. In her stories and columns, she spoke out against racism, sexism, ageism, and other harmful biases. She believes one should not let race and gender bias become a barrier to progress and opportunity. (Courtesy of Palo Alto Historical Association.)

To address the lack of modeling opportunities for African Americans in 1968, Lula Briggs Galloway, a graduate of James Lick High School, opened a modeling agency, Media Masters, in San Jose at the age of 24. Her agency started with eight models from all racial groups. Galloway loved history and often dreamed of having an African American Heritage House (AAHH) in San Jose, but she died before it became a reality. The AAHH that exists in San Jose today is the fulfillment of her dream. (Courtesy of Ocie Tinsly.)

Ellen Rollins has continued the tradition of promoting Juneteenth celebration events in San Jose. She is the CEO of the National Association of Juneteenth Lineage California, and speaks on issues such as healthcare reform and social justice. Since 1990, she has been involved in continuing advocacy concerning community based and transitional health care services. She was named the Women of Excellence in Advocacy. (Courtesy of Ellen Rollins.)

The purpose of the African American Heritage House is to exhibit and explore African American history, culture, and human experiences and to contribute to the continuing history of San Jose. The AAHH is operated by Ocie Tinsly, a board of directors, and a host of volunteers to keep the dream alive and tell the history of the black experience. In the photograph above, Ocie Tinsly is standing outside of the African American Heritage House. At right, he is pictured with his wife, Mattie. (Both, courtesy of Ocie Tinsly.)

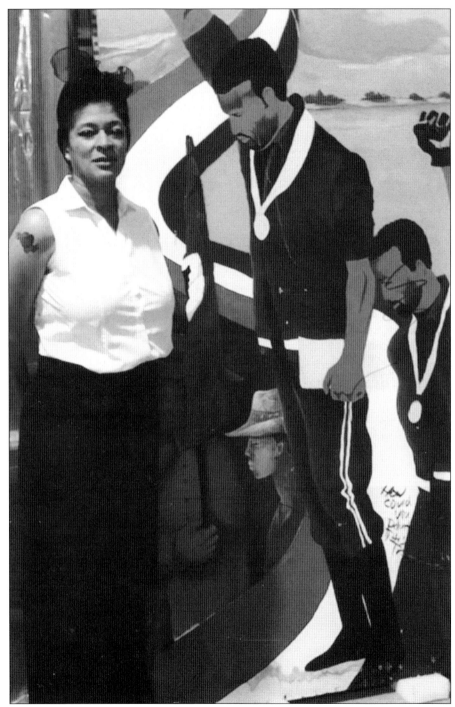

Curator Urla Hill is a journalism graduate from San Jose State University and creator of the exhibit "Speed City: From Civil Rights to Black Power." The exhibit debuted in San Jose in the fall of 1998. It is the only exhibit on San Jose State University's track and field team between 1958 and 1968. Currently, Urla Hill is an educator and continues to research the stories of athletes and coaches from San Jose State University. (Courtesy of Urla Hill.)

Since 2012, Clarissa Moore, creator of the African American History exhibit at First AME Zion Church in San Jose, moved to San Jose in 1986 with Woody Moore and their three children. She is a graduate of the University of Illinois and an educator. For 12 years, she was a program director for National Council for Community and Justice. Since 1986, she has been collecting black history memorabilia and art, which is now available for public viewing. (Courtesy of Clarissa Moore.)

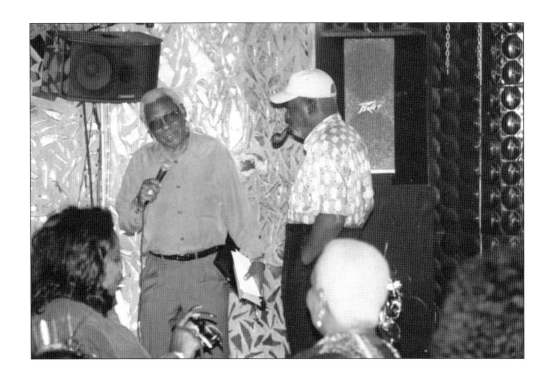

Steve Jackson, owner of the Blue Note Night Club, came to San Jose in 1961 from Denver to work at Lockheed Martin. The Blue Note was previously known as Three Plus. In the 1970s, the biggest problem facing black night club owners was that often the club became stigmatized as a black club and other races would not patronize it. Today, the Blue Note attracts a racially diverse older crowd and hosts a game night on Wednesdays. Below is a banner that identifies the many popular nightclubs in San Jose in the 1960s. (Both, courtesy of Steve Jackson.)

Walter Huddleston came to San Jose in 1954 with his parents and siblings. In 1969, he played the guitar and organ at the Dunbarton club in east Palo Alto. Since the 1970s, Huddleston has owned many night clubs in San Jose and Santa Clara County, such as the Living Room, the Second Movement, and Swahilli Club. He feels it has been difficult for black club owners to succeed given problems with permits, licenses, and obtaining loans to make improvements. (Both, courtesy of Walter Huddleston.)

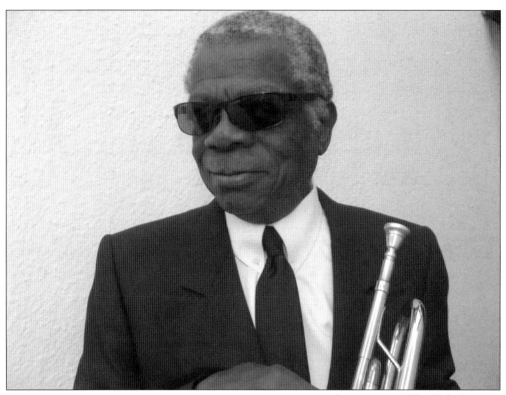

Musician and trumpeter Eddie Gale Stevens Jr., who played with Miles Davis and John Coltrane's bands, moved from New York City to San Jose in 1972. He first performed at the Berkeley Jazz Festival in 1965. In 1974, he was appointed Ambassador of Jazz by San Jose mayor Norman Minetta. Over the years, Gale has visited middle and high schools to introduce students to music. He was an artist in residence in Oakland and San Jose. (Courtesy of Eddie Gale.)

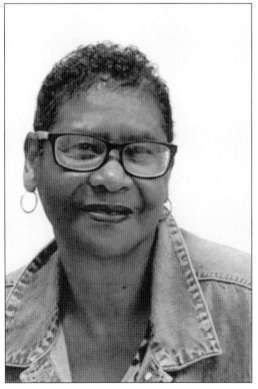

After working for at least 30 years for Raytheon and Fairchild, Sue Mason has applied her skills to building the local chapter of The National Bowling Association (TNBA). She has been president of the San Jose TNBA for 24 years, a certified bowling instructor, and a volunteer with the San Jose City Women's International Bowling Congress tournament for 11 years. In 2018, Mason was inducted into the TNBA Hall of Fame for meritorious service. She serves without seeking fanfare. (Courtesy of Sue Mason.)

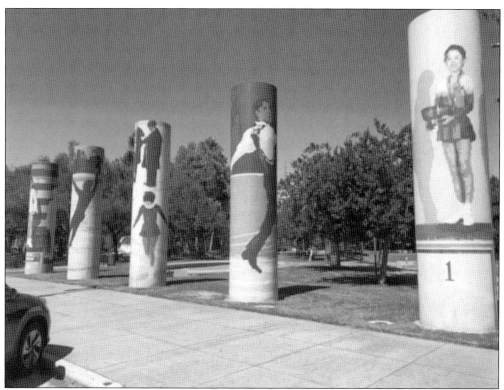

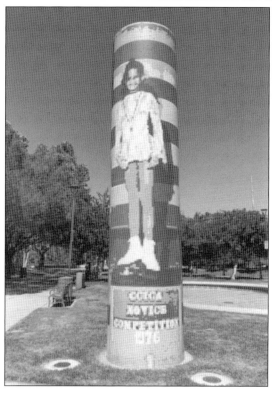

Debi Thomas, who was the first African American to hold a US national title in ladies' single figure skating, started skating at age five in San Jose. She won both the 1986 US national title and the 1986 world championship. She was only the second female athlete to win both titles while attending college full-time. Thomas won the bronze medal at the Winter Olympics in Calgary in 1988. She was the first African American to win an Olympic medal in figure skating. She graduated from Stanford University in 1991 in engineering and earned her medical degree in 1997. This sculpture, titled *Five Skaters*, by artist Mike Mandel and Larry Sulton, was funded in 1996 by the San Jose Arts Commission. The plaques states: "In Honor of San Jose Area Figure Skating Champions." The sculpture shows Brian Boitano, Peggy Fleming Jenkins, Rudy Galindo, Debi Thomas, and Kristi Yamaguchi. They are located across from the SAP Pavilion in San Jose. (Both, courtesy of Jan Adkins.)

Stephen Anderson, a tight end for the NFL's Houston Texans and a 2010 graduate of San Jose's Piedmont Hills High School, started playing football at age seven. After high school, Anderson played four years at UC Berkeley. For the last two seasons, he has played with the Texans. In June 2018, Anderson held his inaugural Elevate Our Youth Foundation Football Camp at his alma mater, Piedmont Hills High School in San Jose. A total of 121 youth, ages 7–14, from eastside San Jose had an opportunity to learn new skills from an NFL player. At UC Berkeley, Anderson was a scholar athlete who displayed a strong work ethic and leadership, which is what he hopes to reinforce to the youth attending his camp. Piedmont Hills varsity players served as volunteers at the camp. Anderson believes in giving back, and at the end of the camp, he made a sizeable donation to Piedmont Hills High School. (Above, courtesy of Pierre Whitsey; below, courtesy of Charlene Anderson.)

BIBLIOGRAPHY

Arbuckle, Clyde. *History of San Jose*. San Jose, CA: Smith and McKay Printing Co, 1986.

Arnold, Harriet. *Chronicles of an African-American Church, 1893–1993*. San Mateo, CA: Western Book Journal Press, 1993.

Beasley, Delilah. *The Negro Trail Blazers of California*. Fairfield and Vacaville, CA: James Stevenson Publisher, 2004, 1918.

De Graff, Lawrence B., Kevin Mulroy, and Quintard Taylor. *Seeking El Dorado: African Americans in California*. Seattle, WA: University of Washington Press and Autry Museum of Western Heritage, 2001.

Edwards, Harry. *The Revolt of the Black Athlete*. Champaign, IL: University of Illinois Press, 1969, reprinted: 2017.

Forbes, Jack D. *Afro-Americans in the Far West*. Berkeley, CA: Far West Laboratory for Educational Research and Development, 1966.

Gage, Henry, Cowander V. Gage, and Sabrina V. Gage. *Plantation Life on Old River and Beyond. An Autobiographical Story Based on the Life of Henry Gage, Sr.* Bloomington, IL: Author House, 2008.

Garden City Women's Club Inc. *History of Black Americans in Santa Clara Valley*. Sunnyvale, CA: Lockheed Martin Space Systems Company Inc., 1978.

Lapp, Rudolph M. *Blacks in Gold Rush California*. Binghamton, NY: Vail-Ballou Press, 1977.

McDonald, Emanuel B. *Sam McDonald's Farm: Stanford Reminiscences*. Stanford, CA: Stanford University Press, 1954.

Ruffin, Herbert G. II. *Uninvited Neighbors: African Americans in Silicon Valley, 1769–1990*. Norman, OK: University of Oklahoma Press, 2014.

Wexler, Deborah. "A History of the African American Community in Palo Alto, California." San Jose, CA: San Jose State University, 2009.

DISCOVER THOUSANDS OF LOCAL HISTORY BOOKS FEATURING MILLIONS OF VINTAGE IMAGES

Arcadia Publishing, the leading local history publisher in the United States, is committed to making history accessible and meaningful through publishing books that celebrate and preserve the heritage of America's people and places.

Find more books like this at
www.arcadiapublishing.com

Search for your hometown history, your old stomping grounds, and even your favorite sports team.

Consistent with our mission to preserve history on a local level, this book was printed in South Carolina on American-made paper and manufactured entirely in the United States. Products carrying the accredited Forest Stewardship Council (FSC) label are printed on 100 percent FSC-certified paper.

MADE IN THE USA